BLAST

COUNTERBLAST

BLAST

COUNTERBLAST

Edited by
Anthony Elms
& Steve Reinke

Mercer Union
A Centre for Contemporary Art
1286 Bloor Street West
Toronto, Ontario M6H 1N9
+1 416 536 1519
www.mercerunion.org

ACKNOWLEDGEMENTS
Mercer Union acknowledges the generous support of its membership,
the Canada Council, the Ontario Arts Council and the City of Toronto
through the Toronto Arts Council. This publication is funded through
a Media Arts Dissemination Grant from the Canada Council for the Arts.

EDITORS: Anthony Elms, Steve Reinke
MANAGING EDITOR: Sarah Robayo Sheridan
COPY EDITOR: Deanna Wong
INTERN: Ellyn Walker
DESIGN: Underline Studio
PRINTING: Friesens, Altona, MB, Canada

Published by Mercer Union, Toronto / WhiteWalls, Chicago, 2011
Distributed by the University of Chicago Press
Printed and bound in Canada
© 2011 Mercer Union / WhiteWalls

Library and Archives Canada Cataloguing in Publication

Blast counterblast / edited by Anthony Elms and Steve Reinke.

ISBN 978-1-926627-17-5

1. Mass media and art. 2. Visual literature. 3. Art, Modern—
Social aspects. 4. Art and literature. I. Elms, Anthony
II. Reinke, Steve, 1963–

N72.M28B53 2011 700.1 C2011-906907-5

A book about the suspension of time and space, about the
future and about the possibility to move freely along
all coordinates simultaneously, about the realization that
everything is impossible but lies open before each and
every one of us, about miracles, about the inevitable desire
to dominate the world, about violence and about death
as a lifelong friendship.
LEIF ELGGREN

Contents

THE MODERN BLACK SABBATH

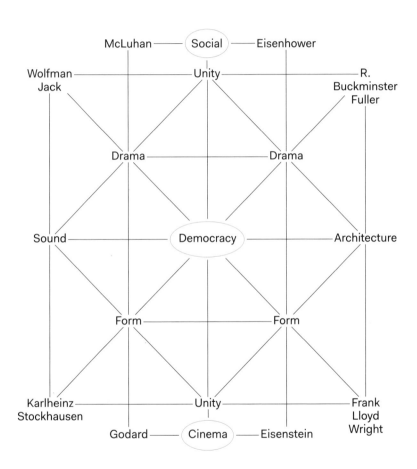

A Young Person's Guide to Humour

Introduction
ANTHONY ELMS & STEVE REINKE

In 1969, there appeared *COUNTERBLAST*. Marshall McLuhan, the entrepreneur, was the perpetrator of this counterblast. McLuhan's introduction:

"In 1914, a few weeks before the war, there appeared from the Rebel Art Centre in London, *BLAST*. Wyndham Lewis, the painter, was the perpetrator of this blast. The word is a jest derived from blastoderm, a term from embryology. Lewis also had reference to *THE GERM*, the Art magazine put out by the Rossetti Circle. *BLAST*, typographically, is unique in the history of English literature. Lewis told me that he found it impossible to get it set up by any London printer whatever. He finally found an alcoholic ex-printer who agreed to set it up exactly as Lewis required in return for large supplies of liquor. Nearly the entire magazine is set up in heavy headline type. Headlines are icons, not literature.

"Certainly the present work makes no claim to be literature, but it is just as difficult now as in the time of Lewis to get any prose or verse set up in headline type.

"In 1954, Wyndham Lewis blasted Toronto in the novel *SELF CONDEMNED*. His Rene (reborn) seeking his true spiritual self selects Toronto, Momaco (Mom & Co.), as a colonial cyclotron in which to explore his human ego. He succeeds in annihilating himself.

"In *AMERICA AND COSMIC MAN* Lewis saw North America as a benign rock-crusher in which all remnants of European nationalism and individualism were happily reduced to cosmic baby powder. The new media are blowing a lot of the baby around the pendant cradle of the New Man today. The dust gets in our eyes.

"The term *COUNTERBLAST* does not imply any attempt to erode or explode *BLAST*. Rather it indicates the need for a counter-environment as a means of perceiving the dominant one. Today we live invested with an electric information environment that is quite as imperceptible to us as water is to a fish. At the beginning of his work, Pavlov found that the conditioning of his dogs depended on previous conditioning. He placed one environment within another one. Such is *COUNTERBLAST*."

As *COUNTERBLAST* is to *BLAST*, *BLAST COUNTERBLAST* is to both *BLAST* and *COUNTERBLAST*. This present work is beyond literature, and well advanced beyond Lewis and McLuhan: in our times it is easy to get whatever prose or verse you desire set up in headline type.

WITHOUT WHICH
(PRELIMINARIES)

B
L
A years 1837 to 1900
S Curse abysmal inexcusable middle-class
T (also Aristocracy and Proletariat).

Pasty shadow cast by gigantic Boehm

B
L (imagined at introduction of BOURGEOIS
 VICTORIAN VISTAS).
A
S WRING THE NECK OF all sick inventions
 born in
T
 that progressive white wake.

Our vortex is not afraid of the past:
It has forgotten its existence.

(Wyndham Lewis, *BLAST* 1, 1914)

Wyndham Lewis and Mark E. Smith

STUART BAILEY

As with Joyce, Beuys and Mark E. Smith, the historians will be arguing about (Percy) Wyndham Lewis until the kingdom comes. Twentieth century culture has been kept alive by the irritants which work their way under its skin. In this much, McLuhan's call for "the need for a counter-environment as a means for perceiving the dominant one" required a new century to prove its accuracy. Wyndham Lewis, who could so easily be the subject of a myriad quarterly reviews, has remained a shadowy and mistrusted figure, silhouetted on the banks of the cultural mainstream. As our times appear to demand art terrorist outsiders, Lewis has called the era's bluff by refusing easy routes to fashionable and commercially-lucrative acceptance. While Marinetti caught, peeled and ate the orange thrown at him in public disgrace, Wyndham Lewis—unknown to many—continues to ply his trade as a novelist, satirist, poet, critic of literature, philosophy and art, magazine editor, painter and fly-in-the-ointment.

Lewis formed the Vorticist group (as the point of maximum energy) in London in 1914. At the time, he was painting and writing around the fringes of London's Bloomsbury, later from the Rebel Art Centre, which he co-founded with Kate Lechmere. This was a time when most of Europe was largely unsuspecting of the imminent war, only a few months away. The studied neurosis of Realism and Impressionism was about to give way to the deliquescing anarchy of Cubism and Expressionism. But the Vorticists had no place—nor wanted one—in either camp. From their inception, Lewis's Vorticists were bloody-minded outsiders, possessing an extraordinary ability to get up noses. At a time when Post-Impressionism was about to disgrace itself with the saccharine

posturing of Abstraction, Lewis appeared equally comfortable in the regulation uniform of trench warfare, as much as the louche smoking jacket of his gentleman's club. In 1914 art was reinventing itself as a minefield of carefully stylized factions; the Vorticists, immovable in their determination to remain aloof from the posturing of their peers, quickly earned not only incomprehension but also hostility. In an early appearance at one of Marinetti's London speeches at the Doré Gallery, Lewis and company brought the volatility of a working men's club to a scene which believed itself to be self-contained and self-policing. The rhetoric of the Vortex was similar to suddenly finding oneself in a slanging match with a chauvinist, fascist, intellectual drunkard. For this invective Lewis has never been forgiven. Challenged with the notion that the Vorticists drew their menace from the seismic detonation of Futurism, Lewis replied with a dismissive sniff, "Automobilism—Marinettism— bores us. We don't want to go about making a hullo-bulloo about motor cars, anymore than about knives and forks, elephants or gas-pipes. Elephants are VERY BIG. Motor cars go quickly."

Like Marinetti's Futurist Manifesto, Lewis's *BLAST* magazine was regarded as the alarm call of the pre-war years; this was polemic which seemed to deal with personal and political dissatisfaction in a manner which was both sinister and confrontational. By the end of the decade the Futurists resembled a self-parodic cabaret turn fit only for the history books. The Vorticists, on the other hand, made their sense of alienation part of their art, laying the foundations for a creative process which was almost immediately disrupted by a war which saw them divided, dispersed and, in some cases, killed in action. For Wyndham Lewis, irreverence was put to work for Vorticism. As the self-titled "Enemy," he would parade around London's art and literary circles shouting random insults at the bewildered cognoscenti. The Futurist statue will move: then it will live a little: but any idiot can do better than that with his good wife, round the corner, "This war talk, sententious execution and much besides, Marinetti picked up from Nietszche" or, "I loathe anything that goes too quickly.

If it goes too quickly it is not there" when delivered with the correct mixture of urgency and forethought, could obtain an effect that bordered on the sinister.

It was only a short step, aesthetically, from confusing Marinetti and the Futurists with dismissive put-downs to offending the art cognoscenti by challenging their self-satisfaction. *BLAST* was jarring and disjointed, making a virtue of its graphic appearance, faithfully set according to The Enemy's bombastic wishes by an alcoholic ex-printer between startling puce covers:

> The "Poor" are detestable animals! They are only picturesque and amusing. The "Rich" are bores without a single exception, En tant que riches! / We want those simple and great people found everywhere / *BLAST* presents an art of Individuals.

Already, Lewis's campaign bore marked similarities to the Live at the Witch Trials phase of Mark E. Smith's and The Fall's assault on the post-punk new wave. Smith was a Renaissance Man without a culture vital enough to support the fulfillment of his talents. Similarly, Lewis is locked in a position of terrorist warfare, cerebral and caustic against a fashion-driven society which is indurate to all attitudes save its own conservative "non-conformity." Thus Lewis is cast (again like Smith) as a cat amongst pigeons, stalking the effete by saying the unspeakable. In 1914 Lewis wrote:

<div align="center">

OH BLAST FRANCE!

pig plagiarism
BELLY
SLIPPERS
POODLE TEMPER
BAD MUSIC

SENTIMENTAL GALLIC GUSH
SENSATIONALISM
FUSSINESS
PARISIAN PAROCHIALISM.

</div>

Or again:

As to women: wherever you can, substitute the society of men. Treat them kindly, for they suffer from the herd, although of it, and have many of the same contempts as yourself. But women, and the processes for which they exist, are the arch conjuring trick: and they have the cheap mystery and a good deal of the slipperiness, of the conjuror. Sodomy should be avoided, as far as possible. It tends to add to the abominable confusion already existing.

Whist Lewis's polemic continues to affront every notion of political correctness, his audience recognizes that his contrariness is merely a facet of a far more complex, and engaging, world vision. The ability to provoke and doubt, simultaneously, has often been cited as being fundamental to great art. Lewis himself went some way to acknowledging this in 1917: "You must be a duet in everything. For the individual, the single object, and the isolated is, you will admit, an absurdity. Why try and give yourself the impression of a consistent and indivisible personality?"

From the very beginning, Vorticism has been Wyndham Lewis's medium for expressing his unique world view: everything outside the Vortex is meat for his stew. Within the chaos of Vorticism, and within the oblique, humorous code of Lewis's writing, there are precise patterns and a finely focused lucidity. He assembles his words in such a manner that found language, narrative, slang, double-talk, trigger phases and rapid juxtapositions are combined to create a discourse which describes as it commentates. The style is not artless, as it may seem, but the product of careful design. "Life is what I have gone out to get" says Lewis, "—life where it is merging with something else, certainly. But I catch it just before it goes over into the fastuous element. The fish is still in the stream. Or if you like, this is the raw meat in the kitchen—destined, perhaps, for the Banquet of Reason, but as yet highly irrational."

Like Mark E. Smith, Wyndham Lewis will suggest the

existence of a conspiracy behind most manifestations of modern culture. In texts such as "Enemy of the Stars," "Life is the important thing," "Policeman and artist," "Orchestra of the Media," "Tarr," and "Code of a Herdsman," Lewis appears to endorse what Smith meant by "the war against intelligence." In 1937 Lewis stated: "Do not play with political notions, aristocratisms or the reverse, for that is a compromise with the herd. Do not allow yourself to imagine 'a fine herd though still a herd.' There is no FINE HERD. The cattle that call themselves 'gentlemen' you will observe to be a little cleaner. It is merely cunning and produced with a product called SOAP. But you will find no serious difference between them and those vast dismal herds they avoid. Some of them are very dangerous and treacherous."

If Vorticism is both Lewis's vision of the world and his means of describing it, then the Great British Vortex is peopled with grotesque characters whom Lewis has invented. These would include BRITANNIC AESTHETE, WILD NATURE CRANK, DOMESTICATED POLICEMAN, GAEITY CHORUS GIRL, AMATEUR, SCIOLAST, ART-PIMP, JOURNALIST, SELF-MAN, ORGANIST, and THE HAIRDRESSER. One gets the impression that Lewis's imagination was incubating this cast since before Vorticism began. In many ways his writing has served to fill the biographies of these characters; at the same time Lewis will write pseudonymously under their names. In a later autobiographical piece entitled "The 'Author of *Tarr*,'" he begins, "So much for Mr Cantleman. Need I repeat that this hero of mine is not to be identified with me? But to some extent, in the fragments I have just quoted, you get the lowdown on the editor of *Blast*. That is why I used them."

When asked to clarify this assessment of these characters, Lewis cautiously sips his beer before replying

Never fall into the vulgarity of assuming yourself to be one ego. Each trench must have another one behind it. Each single self—that you manage to be at any given time—must have five at least indifferent to it. You must have a power of indifference of five

to one. All the greatest actions in the world have been five parts out of six impersonal in the impulse of their origin. To follow this principle you need only cultivate your memory.

"In order to live you must remain broken up," Lewis announced in 1917. Whilst critics have yet to agree whether the Vorticists, artistically, are drab or dynamic, the roots of mesmeric intensity lie in the practice of contradiction. In the most compelling Lewis texts, the language and typography merely provides an open structure through which Lewis roams like a suspicious caretaker, flashing his torch from one empty dark room to another. This is best illustrated in *BLAST*'s "Manifesto," signed by ten others.

The seven-part polemic begins with a ten-point prologue in which Lewis declaims:

1 Beyond action and reaction we would establish ourselves
2 We start from opposite statements of a chosen world. Set up violent structure of adolescent clearness between two extremes
3 We discharge ourselves on both sides
4 We fight first on one side, then on the other, but always for the same cause, which is neither side or both sides and ours

As Lewis explains, the idea of the Vorticists was always to create a violent central activity, attracting everything to itself, absorbing all that is around it. "Vorticism was an intellectual eruption, productive of a closely-packed, brightly-coloured alphabet of objects with a logic of its own. The doctrine which is implicit in this eruption is to be looked for in the shapes for which it was responsible...I should have encouraged the shaping, in clay or in wood, of objects conforming to these theories. In other words, a world of not-stone, not-trees, not- dogs, not-men, not-bottles, not-houses, etc."

Initially, the received idea of the Vorticists' audience was that of pale, tall, exceedingly romantic-looking fellows. The obscurity of The Vortex appeared to demand supporters who were socially dysfunctional—the weird cousins of the Bloomsbury Group. In time, however, the Vorticists have achieved a certain following alongside fellow modernists such as James Joyce, Ezra Pound and T.S. Eliot.

It was scarcely our fault that we were a youth racket. It was Ezra who in the first place organized us willy nilly into that. For he was never satisfied until everything was organized. And it was he who made us into a youth racket—that was his method of organization.

All politics today, and all the "youth-racket" element in politics are put across by men- of-letters, journalists, philosophers, or the propaganda of intellectualist sects, groups and philansteries, rather than via the Clubs or the floor of the House of Commons. And as I have already indicated, there was a tidy bit of political contraband tucked away in our technical militancy. But I was not the responsible party.

Yes, Mr Joyce, Mr Pound, Mr Eliot—and, for I said that my piety was egoistic, the Enemy, as well—the Chiricos and Picassos, and in music their equivalents—will be the exotic flowers of a culture that has passed. As people look back at them out of a very humdrum, cautious, disillusioned society, the critics of the future day will rub their eyes. They will look, to them, so hopelessly avant-garde! so almost madly up-and-coming!

What energy!—what imposssibly Spartan standards man will exclaim! So heroically these "pioneers" will stand out like monosyllable monoliths—Pound, Joyce, Lewis. They will acquire the strange aspects of "empire-builders," as seen by a well-levelled and efficiently flattened-out Proletariat, with all its million tails well down between its shuffling legs!

But, despite their position as a "difficult" group already at odds with shifting cultural fashions, the Vorticists' Luddite tendencies have brought them into the focus of serious debate about contemporary art.

The Arts with their great capital A's are, considered as plants, decidedly unrobust. They are the sport, at the best, of political chance: parasitically dependent upon the good health of the social body.

A few arts were born in the happy lull before the world-storm. In 1914 a ferment of the artistic intelligence occurred in the west of Europe. And it looked to many people as if a great historic "school" was in process of formation. Expressionism, Post-impressionism, Vorticism, Cubism, Futurism were some of the characteristic nicknames bestowed upon these manifestations, where they found their intensest expression in the pictorial field. In every case the structural and philosophic rudiments of life were sought out. On all hands a return to first principles was witnessed.

Wyndham Lewis's writing anticipates and rejects academic criticism, although he has offered analyses of his work. Of his various *BLAST*s (1914) Lewis says, concisely: "Take the first *BLAST*, 'Blast Humour.' That is straightforward enough. The Englishman has what he calls a 'sense of humour.' He says that the German, the Frenchman, and most foreigners do not possess this attribute, and suffer accordingly. For what does the 'sense of humour' mean but an ability to belittle everything—to make light of everything? Not only does the Englishman not 'make a mountain of a molehill;' he is able to make a molehill out of a mountain." The more ambitious *Tarr* (1914–15), a terse first novel of verbal economy, was summarized by Lewis as displaying "a certain indifference to bourgeois conventions, and an unblushing disbelief in the innate goodness of human nature."

Lewis, spokesman of "The New Egos," maintains a similar single-mindedness toward the traditionally sensitive subject of politics. "I am trying to save people from being 'ruled' too much—from being 'ruled' off the face of the earth, as a matter of fact."

But would Lewis invest, seriously, in politics?

Really all this organized disturbance was Art behaving as if it were Politics. But I swear I did not know it. It may in fact have been politics. I see that now. Indeed it must have been. But I was unaware of the fact: I believed that this was the way artists were always received; a somewhat tumultuous reception, perhaps, but after all, why not? I mistook the agitation in the audience for the sign of an awakening of the emotion of artistic sensibility. And then I assumed too that artists always formed militant groups. I supposed they had to do this, seeing how "bourgeois" all Publics were—or all Publics of which I had any experience.

Anyhow, in 1926 I began writing about politics, not because I like politics but everything was getting bogged in them and before you could do anything to deal with the politics with which it was encrusted. And I've got so bepoliticked myself in the process that in order to get at me, today, you have to get the politics of me first. However, when politics came on the scene I ring down the curtain; and that was in 1926. That was when politics began for me in earnest. I've never had a moment's peace since.

Inevitably, Lewis is in danger of becoming as marginalized as Mark E. Smith became in his later and most prolific years. As yet, however, the Vorticists remain a question mark in the history of art. But Lewis continues to rant. "Peace is a fearful thing for that countless majority who are so placed that there is no difference between Peace and War— except that during the latter day they are treated with more

consideration. In war, if they are wounded they are well treated; in peace, if struck down it is apt to be nothing like so pleasant."

You will be astonished to find out how like art is to war, I mean "modernist" art. They talk a lot about how a war just-finished effects art. But a war about to start can do the same thing. War, art, civil war, strikes, coup d'états dovetail into each other. It is somewhat depressing to consider how as an artist one is always holding up a mirror to politics without really knowing it. My picture called *The Plan of War* painted six months before the Great War "broke out," as we say, depresses me. A prophet is a most unoriginal person: all he is doing is imitating something that is not there, but soon will be. With me war and art have been mixed up from the start. It is still.

This piece, originally published in *Metropolis M*, no. 2, 2005, is an inversion of a piece by Michael Bracewell and Jon Wilde, "Mark E. Smith," originally published in *Frieze*, no. 6, 1992.

Lewis's "conversation" is drawn from his various writings, particularly his autobiography *Blasting And Bombadiering* (1937).

Stuart Bailey

Dear Living Person

JOHN RUSSELL

Dear Living Person,

By the time you read this I will already be hanging from the ceiling of my live-work studio flat. My neck stretched to allow my feet to touch the floor, with the rope pulling at my neck so as to twist my head in an attitude as if casually looking out of the window, gazing at the territorialised conformity of the street below. People walk back and forward like banal cunts on their way to work or to pick up a coffee or some other shit. It looks like I'm standing here looking out the window.

Ten minutes ago, the people who recently moved into the warehouse flat downstairs popped up with a bottle of wine to introduce themselves. They thought I was just standing here—maybe thought I was a bit deaf or something—and walked right across to me, click-clacking on the sanded, wooden floor boards. And tapped me on the shoulder—they only realised I was dead when they saw my blackened face and the fly walking across my eye. I guess they may be moving out now.

I can feel the bluebottle fly (*Calliphora*) laying its eggs in my eye. They find you quickly when you die—seize the opportunity. Pale whitish larvae will soon hatch. It's getting dark outside.

Some heavy shit happened to me when I was young, but it could be argued that it was the architecture of this building that really tipped things over the edge. These ex-warehouse units are fucked. Nothing is parallel or forty-five degrees. It's all over the place. Plays with your mind over a period of time, because you are living in it and you can't get away. The floors in particular are fucked. You walk up a slope from the living room area to the small kitchen. Fucks with your head.

The guy from downstairs has just popped back up again—turns out he's a necrophiliac. He's just spent fifteen minutes fucking me up the arse. God knows what that felt like—fucking my bony old ice-arse—can't have been the best. He was crying in the end. That's all a bit too weird for me. And now I've got his spunk dripping down my leg. He didn't even give me a reach-around ha ha ha!

Anyway my last artworks are all lined up over there, against the wall, if you fancy a look. It's my *Ivory Series*. Oil paintings of ivory carvings (and a few marble ones). Of animals and humans. It's the whiteness that interests me. The representation of the shininess on white sculpture. Have you read *Moby Dick*? Yeah… the way white is used there. And… err… also referring to the whiteness of the white cube? Yes… they *are* a bit like Michael Krebber…

I'm a big fan of Michael Krebber, and his group of friends in Cologne—I love the language they use, mockery, irony, light digressions and particularisms—it's such an amazingly truthful, intelligent, loving, inclusive social scene. And man I'm so grateful to Michael…for the way by becoming a tortured, contorted human bridge between the dinosaurs of 80s German painting and new, radically contextualised, gendered, "gayed" and thereby politicised art networks… he, in a sense, gave me permission to paint.[1]

It's weird because I just got a phone call from the studio of Cosima von Bonin asking if I want to be in a group show they're organising called Various Angels at Gallerie Buchholz which is soooo cool. My ivory paintings will just fit in so well. I'm very happy about that.

But the problem is, as always, the issue of the frame or limit… as with Michael Krebber, it's all about frames and limits. If his work is a marker for a kind of work that doesn't exist (yet) because the kind of situation required to allow that kind of work to exist doesn't exist (yet)—or something like that. Then that's about limits. It always is, whether you are referring to medium specificity, institutional critique, the readymade or the relationship between art and non-art, text/image, critical/uncritical, politics/aesthetics, inside/outside and so on. It's

[1] Quoted from Merlin Carpenter, "The Sound of Bamboo," 2000. http://www.merlincarpenter.com/sound.htm

always about limits. About playing out the relationship between the finite and the infinite.[2] And, by extension, playing out the relationship between life and death. The *limits* between life and death. And this is always the same. An irresolvable, irretrievable non-relationship descending into mournful realms. That's my feeling…

To explain this. What is important here is the legacy and/or prophesy and/or curse of conceptual art that spirals out at us from the 1960s/70s as a "discourse of limits." This legacy bleeds out of the second coming of Duchamp (in the 1960s) and resurgence of critical interest in his ideas of the readymade. As a reaction to the various (Modernist) configurations of medium specificity. Following Pop Art and Minimalism, it contests *what* might be articulated as art. Experimenting with (for instance) popular culture as art, non-specific objects as art, politics as art, idea as art, performance as art. And then, following the realisation that anything *might be* art but not everything *is* art, the focus switches to *how* or *when* things *are* articulated as art. That is, constituted (as art) not through the simple placement of an object in a museum but through social relations of recognition which constitute the institution, which constitute the art object. And the realisation that in constituting objects as art, art institutions also function in various (non-artistic) social and political ways. And so, institutional critique develops as a critique of the art institution as a legitimising structure (of the specialness of art, of class structure, etc.) and involves attempts to: "analyse and expose the social institutions from which the laws of positivist instrumentality and the logic of administration emanate in the first place." The very institutions "in which artistic production is transformed into a tool of ideological control and cultural legitimation."[3] This involves a continuous (critical) staging of the institutional production of the object as art, as a discourse of limits (the staging and re-staging of limits). After which, it was claimed, would follow a discourse of rupture.[4] "The artist, if he wants to work for another society, must begin by fundamentally contesting art and assuming his total rupture with it. If not, the next revolution will take over his responsibility."[5] But it is

[2] As first glamourised in Jena Romanticism whereby "the work of art unites the realms of necessity and freedom epistemology and ethics, or the sensuous and the intelligible that Kant had sundered." Simon Critchley, *Very Little… Almost Nothing: Death, Philosophy, Literature* (Warwick Studies in European Philosophy), Routledge 1997, p.105.

[3] Benjamin Buchloh, "Conceptual Art 1962-69: From the Aesthetic of Administration to the Critique of Institutions," *October*, 55 (Winter 1990), p.143.

[4] For instance see Daniel Buren, "Critical Limits" (1970), in his *Five (5) Texts*, New York: John Weber Gallery, and London, 1973.

[5] Daniel Buren, *Is Teaching Art Necessary?* June 1968, Galerie des Arts, September, 1968, here quoted from Lucy Lippard, *Six years: The dematerialisation of the art object from 1966 to 1972*, Berkeley: University of California Press, 1973, p.51.

difficult to understand what format this rupture might take,
what it would do, or how it would happen. If an artist maintains
a "critically" located position, the critical or political content
and/or performance of the work is inevitably staged within the
structures of which it is critical and which it relies upon for
its visibility. This is a kind of critical not-belonging, as Hans
Haacke suggests, the "contradictory position of playing the
game while criticising it."[6]

In this respect, institutional critique has moved from
a critique of the art museum and gallery (1960s and early
1970s), to a critique of the artist's role—the subject performing
the critique—as institutionalised (from the 1980s onwards),
to a critique of the audience as a constituent part of the insti-
tution (2000 onwards, although this also seems like a return
to previous models, e.g., Manet).[7] As well as this, more recently
there has also been a move away from anti-institutional
modes, to less confrontational models of negotiation and
transformation. A move away from the attempt to oppose or
even destroy the institution to an attempt to modify and
solidify it.[8] For instance, Nicolas Bourriaud's ideas of "relational
aesthetics" where artistic praxis exists as a context (or lab-
oratory) for experiments with new "models of sociability" and
social interaction, as a form of micro-utopian politics, takes
place in the *institution-as-oasis*, pitched against a world
where "human relations are no longer 'directly experienced,'
but have become blurred in their 'spectacular' representa-
tion."[9] Amongst others, Claire Bishop has problems with the
political potential of Bourriaud's ideas, proposing instead the
concept of *antagonism* drawn from ideas of radical democracy
and arguing that a democratic society is one in which relations
of conflict are sustained, not erased, and therefore in which
new political frontiers are constantly being drawn and brought
into debate.[10] And then, more recently still, the artist/theorist
Andrea Fraser has suggested that a movement between an
inside and an outside of the institution is no longer possible.
As she writes, "with each attempt to evade the limits of institu-
tional determination, to embrace an outside, we expand
our frame and bring more of the world into it. But we never

[6] Robert Morgan, "Interview with Hans Haacke," December 28, 1979, in Robert Morgan, *Conceptual Art: An American Perspective*, Jefferson, North Carolina: McFarland & Company, 1994, p.157.

[7] See James Meyer's essay "What Happened to Institutional Critique?," *American Fine Arts*, 1993.

[8] Simon Sheikh, "Notes on Institutional Critique." 2006. *Transversal Online Journal*, Eipcp.net, http://transform.eipcp.net/transversal/0106/sheikh/en

[9] Nicolas Bourriaud, *Relational Aesthetics*, Dijon: Presses du Réel, 2002, p.18; Ibid, p.9.

[10] Claire Bishop, "Antagonism and Relational Aesthetics," *October*, 110 (Fall 2004), 52; For a discussion of radical democracy see, for example, Laclau and Mouffe, *Hegemony And Socialist Strategy: Towards A Radical Democratic Politics*, Verso, 1995.

escape it."[11] "We are the institution," Fraser writes and concludes that it is not a question of critiquing the institution, but rather a question of creating critical institutions, what she terms "institutions *of* critique," established through self-questioning and self-reflection.[12] Fraser also writes that the institutions of art should *not* be seen as an autonomous field, separate from the rest of the world, in the same way that "we" are *not* separate from the institution. Thus only negotiating and refining new articulations of limits, new variations and new nuances of the "we" of the institution, us/them, escape/no-escape and so on.

The problem here is that all these performances (testing/experimentation/politics/withdrawal/play) are tied to the limits of the institution (in their *critical* function), reproducing *or representing* the means of their own (critical) confinement or articulation. The emphasis is always on limits, set against a background of art historical moves that emphasise *transgression*, a *going beyond* or *expansion*. For instance, the move from medium specificity to art in the expanded field, to art in general and so on. Not so much a crisis of limits as a *trauma of limits*. An anxiety regarding boundaries and the dialectic between located and unlocatedness. That is: what is contained, what is excluded, what is allowed, what is censored, what can be transcended, what is visible and what is invisible and how this is registered, monitored, authorised. Fuck… my fingers… keep moving…jerking. That is, the relationship between the small world of art and everything else.[13] The non-dialectic of existence and non-existence. And finally, as I proposed earlier, this ongoing negotiation of limits ends up mirroring the binaries of finite/infinite and life/death.

This can be most clearly seen in the example of work that tries to escape "cultural confinement;" work which attempts to accelerate away from limits and limitation.[14] Here we can see the discourse of art/non-art played out most clearly. Think of the work of Robert Smithson and Dan Graham in the 1960s, or more recently Seth Price's appropriated films and the spirit of Hito Steyerl's recent, much lauded "In Defense

[11] Andrea Fraser, "From the Critique of Institutions to an Institution of Critique," *Artforum* (September 2005), p.282.

[12] Ibid. p.283.

[13] Boris Groys, "On the New," *Art Nodes*, UOC, 2002. http://www.uoc.edu/artnodes/espai/eng/art/groys1002/groys1002.html

[14] Robert Smithson, "Cultural Confinement" (1972), in Smithson, *Collected Writings*, 1996, pp.154–155.

15 Hito Steyerl, "In Defence of the Poor Image." *Eflux Journal* 10, November 2009, http://www.e-flux. com/journal/view/94

16 For example: Dan Graham's *Homes for America*, 1966, or *Untitled (Figurative)*, 1968, in *Harper's Bazaar*; Robert Smithson's *The Monuments of Passaic*, 1967, in *Artforum*; Robert Smithson and Mel Bochner's *The Domain of the Great Bear*, 1966, in *Art Voices*; and Seth Price's *Dispersion*, 2002, www. distributedhistory. com/Dispersion2008. pdf

of the Poor Image."[15] These ideas and artworks are played out within the expanded and indeterminate conception of the institution suggested by Graham's or Smithson's magazine works or Seth Price's ideas of dispersion, in which magazines and websites are seen as places where art may or may not be recognised as art, drawing attention to the fact that the institution is in fact the sum of the set of relations of the people it contains and that these constituencies are changeable and dynamic.[16] The artwork has become infinitely spatially expanded and the site of the work of art is the totality of cultural sites within which it is mediated and consumed—performing the potential of art and non-art simultaneously, dependent upon the point of consumption. This is the "dialectic" of art/non-art stretched across infinitely expanding surfaces of consumption. Except the problem here, of course, is that something can only be consumed as *art-and-non-art-simultaneously* from the perspective of art (the art institution). And the frisson of excitement experienced is the flirtation with annihilation. That is, if art is pitched at a wider (mainly non-art) audience, then it risks losing its art status and visibility as art and its differentiation from the chaos of other non-art messages— "everything else." In this context it risks losing itself within the infinity of extra-institutional social relations. In this respect the move toward the possibility of an infinitely expanded institution leaves open problems of indeterminacy both in relation to status as art and to how this indeterminacy might operate. I'm finding it difficult to concentrate here… there are strange spasms running down my left arm, flicking my fingers and thumb.

This is an institutional version of the sublime where the artworld is presented (in a variety of different ways) with an experience of the terror of the infinity of the outside or unlocated. This is the same sublime Robert Smithson humorously points to in his juxtaposition of the finitude of the art world with the infinity of other systems (for instance his juxtaposition of the chronological/historical time of the artworld with the mineral/geological time of *Spiral Jetty* [1970]). A cosmic institutional critique, where art's "thing-ness" is confronted

by a period before consciousness, given-ness, or social relations.[17] *If a tree falls over in the North Pole, in the Jurassic period, does it make a noise?*

What this amounts to, therefore, is not a discourse of limits or a trauma of limits but a *bureaucracy of limits*. A move to art in the expanded field where anything can be art but not everything is art. The move beyond medium specificity to post-medium, post-institutional, art-in-general, art-in-the expanded field, sculpture-in the expanded field, curation in the expanded field, the literary turn, the pedagogical turn, is only the move to infinite generalisation: art-in-general-in-general, the-general-in-the-general, generalisation of the general (rather than a Deleuzian landscape of multiplicity and immanence, for instance). And synchronised with this, a move to a generalised bureaucracy and administration of form. Perhaps that's why there is a lot of work at the moment which presents itself as a catalogue or index of disparate forms and references: materials, ideas, genres, themes, styles (for instance, the work of Steve Claydon operates elegantly in this context).

In this context the curator is the key performer—as organiser, collector, cataloguer, archaeologist, manager and guardian. And for instance, Rancière is the philosopher-par-excellence, as the philosopher of aesthetics-in-general and the generalised interdisciplinary. In a world where there are no categories, we are left to experiment with the senses. A meta-politics and framing of a common sensorium, rearticulating freedom and equality in relation to new relationships between thought and the sensory world, between bodies and their environment, between the circulation of language and the social distribution of bodies.[18] Rancière is the writer of this position, an extra-institutional relational aesthetics. He's not very good, but then this is not a very good position. With the dissolution of genre he offers us a generalised reorganisation of senses in general in general in general in general.

Like a bad press release where things are always "going beyond" or "breaking boundaries," the impetus or desire for a move beyond limits is the curse of conceptual art, which is the curse of transcendence. What began as a desire for

[17] See Quentin Meillassoux, *After Finitude: An Essay on the Necessity of Contingency*, London: Continuum, p.7. And/or Ray Brassier, *Nihil Unbound: Enlightenment and Extinction*, NY: Palgrave MacMillan, 2010, pp.49–96.

[18] For instance, Jacques Rancière, *The Politics of Aesthetic*, Continuum, 2006.

difference becomes a bureaucracy of limits and an administration of generalised multiplicity. This is the desire for difference as the same as different, as opposed to the absolutely different which is *not* the other-as-the-beyond. It is in this distinction between two ideas of "difference" that we see the root of the problem: the fetishism of limits is connected to a particular performance or philosophy of language, specifically deconstruction. As a kind of parergonal fetishisation of limits. As the discourse of "and/or" and the dream of impossible transcendence. Developing out of conceptual art's "linguistic turn," whereby the staging of conceptual art emphasises the fact that the artwork is dependent upon (and created by) the structures and languages of the institution which stage the artwork *as art*, art is twisted to the linguistic.

This can be navigated either art historically via the conventional chronological narrative of morphological transformation (style, movements, trends, etc.); or socio-historically in relation to transformations in the world/society/politics; or in relation to conceptual art's engagement with Anglo-American philosophy of language (Kosuth),[19] or retro-translated via Foucault's ideas of discourse (de Duve).[20] Blood pooling in my legs—bloating out my feet and calves. But whatever the route or genealogy, contemporary art is wedded to the rhythms and cadences of deconstruction which seem to fit seductively and cutely with the sympathies, attitudes and ontologies of contemporary art. This simultaneously allows for "critical" analysis and the re-interpretation of texts whilst maintaining conventional dreams of transcendence (through impossible transcendence)—as a glimpse of something else, of hopeless hope and other familiar art dreams. For instance, Derrida defines deconstruction as the experience of the possibility of the impossible—that is, the (impossible) possibility of the impossible marking "an absolute interruption in the regime of the possible."[21] Marked by their aporetic or antinominal status, their possibility conditioned by their impossibility and so on.[22] And Derrida's understanding of *différence* is as "neither this nor that, neither sensible nor intelligible, neither positive nor negative, neither superior nor inferior, neither

[19] Joseph Kosuth, *Art After Philosophy*, Studio International, October, 1969.

[20] Thierry de Duve, *Kant After Duchamp*, Massachusetts and London: MIT Press, 1997.

[21] Harold Coward and Toby Foshay, *Derrida and Negative Theology*, Albany: SUNY Press, 1992, p.290. Quoted in, Daniel Smith. "Deleuze and Derrida, Immanence and Transcendence: Two Directions in Recent French Thought," in Paul Patton and John Protevi, eds., *Between Deleuze and Derrida*, New York: Continuum, 2003, p.57. He adds "Deleuze, for his part, defines his philosophy, not as a search for the conditions of possible experience, but rather the conditions of real experience. Such is the formula of immanence."

[22] For instance, see Jacques Derrida, *Aporias*, California: Stanford University Press, 1993.

active nor passive, neither present nor absent, not even neutral [...] it 'is' not and does not say what 'is.' It is written completely otherwise."[23]

Transcendence as neither this nor that, marked only by the limit it is beyond and *différence* as "that which is never present as such, is absolutely other, discernible only through its trace whose movement is infinitely deferred, infinitely differing from itself, definable at best, in terms of what it is not."[24] In Derrida, obviously, this is connected to his ideas of desire, where the field of desire is completely ensnared in a field of transcendence. Again, as Smith describes it, "desire has traditionally been defined as an irredeemable ontological lack which, by its very nature, is unrealisable—precisely because its object is transcendent or absolutely other (Good, One, God, Moral Law). From Plato and Augustine to Hegel and Freud, desire has been defined, ontologically, as a function of a field of transcendence, in relation to transcendence (as expressed in an Idea)."[25]

In this "desire" for impossible transcendence, as a kind of Romantic aporetics, art deteriorates into a bad (boring) joke, endlessly repeated. The same joke of impossible transcendence, mourning infinitely its impossibility, as a titillating tragedy of hopeless hope and impossible non-futures and so on. And you can't even pretend you don't get the joke or don't know about the joke or aren't taking part in the joke, unless you are truly ignorant, in which case the joke is on you. Conceptual art as a prophecy of overcoming, ends up as the discourse of the parergon: neither/nor, either/or. The non-dialectic of life/death from the perspective of life (human). Where the "/" becomes the sliding registration of the unregisterable. As Smith writes: "from the viewpoint of immanence, in other words, transcendence represents my slavery and impotence reduced to its lowest point: the absolute demand to do the absolutely impossible is nothing other than the concept of impotence raised to infinity."[26]

This is a procession/recession of limits, from art/non-art, to finite/infinite, to the fiction of the ultimate limit of life/death—the "master-limit" which validates and codes all

[23] Jacques Derrida, *Acts of Literature*, London: Routledge, 1992, p.74.

[24] Daniel Smith, "Deleuze and Derrida, Immanence and Transcendence: Two Directions in Recent French Thought," in Paul Patton and John Protevi, eds., *Between Deleuze and Derrida*, New York: Continuum 2003, p.54.

[25] Ibid. p.58

[26] Ibid. p.62

27 Reza Negarestani,
"Hauntology, or Shady
Vitalism, Eliminative
Culinarism," 2008,
http://blog.
urbanomic.com/
cyclon/archives/
2008/10/hauntology_
or_a.html

28 Ibid.

29 Ibid.

30 Ibid.

other limits. As Reza Negarestani writes, this is an "ontological apartheid" or "instrumental capacity" pseudo-articulating "the vitalism of the living and the givenness of its ontological status (the Ideal) in relation to the fiction of 'the dead.'"[27] A correlation between "the contingent outside qua undetermined and the determinable necessity of being / the living," whereby "only by binding the dead as a negative agency can the living establish its myth of inherent persistence, intelligibility and difference or determination *as such*."[28] A persistence which is mirrored in the limits of capitalism, where "the contingency of the outside […] is subtractively transformed to the intensive necessity of capitalism so as to both extend capitalism to an afforded outside and affirm the existence of capitalism as a necessity."[29] A persistence which is maintained, as in art, by a criticality concerned with the fetishisation of limits as the promise of transcendence.

But how can this situation be unperformed. As Negarestani writes "contra *Žižek*'s reckless negationalism (zombified negativity), negation must be extricated from its instrumental extensity whereby the contingency of the outside is subtractively put into service on behalf of an intensive affirmation of an ideal necessity."[30] In his 2008 essay "The Corpse Bride: Thinking with Nigredo," Negarestani performs this extrication through the image of an elaborate Etruscan torture whereby:

> a living man or woman was tied to a rotting corpse, face to face, mouth to mouth, limb to limb, with an obsessive exactitude in which each part of the body corresponded with its matching putrefying counterpart. Shackled to their rotting double, the man or woman was left to decay. To avoid the starvation of the victim and to ensure the rotting bonds between the living and the dead were fully established, the Etruscan robbers continued to feed the victim appropriately. Only once the superficial difference between the corpse and the living body started to rot away through the agency of worms, which bridged the two

bodies, establishing a differential continuity between them, did the Etruscans stop feeding the living. Once both the living and the dead had turned black through putrefaction, the Etruscans deemed it appropriate to unshackle the bodies, by now combined together, albeit on an infinitesimal, vermicular level.[31]

An image that we *cannot* conventionally interpret as primarily the image of the body tethered to the dead, but rather, more reassuringly, as "the soul *qua* living that is chained to the body *qua* dead."[32] Mind and body, soul *qua* vitality and body *qua* inorganic hardware or instrument, whereby the horror of "intimacy with the dead" can only be sedated by extending the chains to the soul.[33] That is, the philosopher must "fasten us upon the soul in an attempt to reduce the horror of perpetual intimacy with the dead into a torment which will only last for a while."[34] A similar maneuver to Nietzsche's description of how (as Christians-all-of-us) we imagine, or dream of truer and better world(s) beyond appearance but, when we fail to grasp these world(s), or are thrown out, fall into despair at what we believe we have lost (which in fact never existed). Mourning the loss of a higher and better world, we imagine ourselves to be guilty, punished or outcast, which gives meaning to our suffering as punishment for our sinful un-ideality, and simultaneously provides us with the source of our salvation.

And art's embrace of limits as marker of its unknown outside is the auto-justification of its own position as the perspective from which its own transcendence/overcoming may be viewed. This dissolution into everything else, leaving behind the "soul of art" as some generalised idea of "creativity" that remains after all the disciplines/media and limits have been transcended. Rather this… anything… than nothing/ contingency.

Or otherwise, more dynamically, Negarestani's image opens us out onto a landscape beyond the dreams of transcendence and the limits which already never existed. A move from the bureaucracy of equivocity, proportionality and the

[31] Reza Negarestani, "The Corpse Bride: Thinking with Nigredo," *Collapse, Vol. IV: Concept Horror*, May 2008, p.131.

[32] Reza Negarestani, "Instrumental Spectrality and Meillassoux's Catoptric Controversies," 2009 http://blog. urbanomic.com/ cyclon/archives/ 2009/04/ instrumental_sp.html

[33] Ibid.

[34] Ibid.

reorganisation of limits as transcendence, to a univocity where being has only one sense—true ontological "equality" and "repetition," vibrating with the "single clamour of Being for all beings" where "each drop and each voice has reached a state of excess—in other words, the difference which displaces and disguises them and in turning upon its mobile cusp, causes them to return."[35]

[35] Gilles Deleuze, *Difference and Repetition*, London: Athlone, 1994. p.304.

And I was born with an umbilical cord around my neck, nearly hanging myself in my mother's womb. Un-borning me to the absolute contingency and immanence that is anyway what life is. And three years later my brother emerged un-alive, dying an hour before birth from intestinal infection (necrotising enterocolitis) and septicemia. In this present situation I am absolute immanence/contingency. Because here the experience of difference and the beyond is tangible, before it is impossible. Looking back at myself from the position of the non-human and from the perspective of fiction. Amongst infinitely multiplying limits, multiplying infinitely. As limits are dissolved in the blinding light of infinite blackness. And as transcendence is transcended. Death as a kind of rotting backwards. A rotting across the decay. The following questions occur. Am I just a dumb anthropomorphism? Is it possible for me to "think" all this given that I am a corpse? Or is this just fiction? And if it is fiction what is the status of this "perspective" as fiction and as philosophy—given that it is still a perspective?

Looking at my own reflection in the window, in the way I am, now. Mirrored against the night. I'm crawling back at you/me in a "pact with putrefaction," moving back from object to the "already-dead," as a fiction of "the freedom of decay."[36] Rotting backwards (as an object and as an image) from nowhere/nothing. But what is key here is that I am looking back from this perspective, from the eyes of the dead, at my own reflection in the window. Stretch-necked corpse in the window. Eyes flowering with fly larvae.

[36] Reza Negarestani, "The Corpse Bride"

Anyway, guess what—that cock sucker from downstairs—I just realised he nicked my cordless drill on the way out. What a fucker. Because I say my drill but it isn't—it's Andy's from the floor above. I left it out on purpose so he could

get it back. There's a staple gun there as well that belongs to
Serge down the street.

Over the next few hours the green and purple stains
of putrefaction creep up my abdomen like some beautiful
ornate marble; then distension and swelling of the body and
blebbing, with purple transudate spreading.

That guy from downstairs came up again. With a couple
of friends this time. Someone was licking my ring piece for
a while. Must be some kind of extreme necrophilia—people
who like fucking decaying bodies. To be honest it's okay with
me. Eyes bulging, organs and cavities bursting, veins marbling
and the spread of putrefaction stains to neck and limbs. And
as putrefaction spreads—slipping across the surface in a further
play of resignification, the process overlaps and underlaps
in the microscopy of figure, skin, pore, atom—searching for
intelligibility and unintelligibility alike in the shine and sweat
of transformation. A glutinous coming-to-be—oscillating
and repeating across the liquid slick of gore and slime, with
the movement of maggots swarming and bulging beneath
the swilling surface; with the germs fucking and procreating
above and the torso swollen and burst to expose the jellied
organs within—pinks and gay reds—synchronising with the
sunrise out the window.

But anyway, been nice talking to you.

All the best,
A corpse

"Dear Living Person" originally appeared in *Mute* Vol. 3 no. 1, Spring/Summer 2011.

Dear Radical Artist
(Unforgettable You)

LANE RELYEA

Don't tell me, let me guess. Your art is unconventional, multiple, hybrid, diverse. You operate in the amorphous spaces of the everyday. You negotiate multiple spaces of operation. You refuse to confine your projects to the art world, utilizing instead various platforms across a range of fields. Indeed, your agency is so fluid and unbound that you probably defy the very label "artist." If this is true, then you're a cliché. You probably say, along with everybody else, that box-like definitions are inadequate. And you're right. Museums, galleries, objects, mediums, fixed job titles, all these are fading: in their place are millions of platforms. What does it mean when, as happens so often now, an exhibition or art practice or artwork is called a platform? The word has political connotations derived from its use in naming the listed positions publicly adopted by an organized political group (a "party platform," for example). Like most in the art world, you don't mind when a hint of that comes through. But actually the word is borrowed from the engineers, designers and business managers who widely embraced the term in the 1990s to describe increasingly decentralized forms of coordination, whether in computer systems, product design or interactions between different industrial manufacturers, suppliers and work teams. Here a platform denotes a basic underlying architecture, a common workbench that, while itself stable and enduring, is open and flexible enough to allow for a high variety of interfaces, a range of inputs and outputs. Unlike the sense of principled commitment conveyed by a political platform, this kind of platform avoids lasting commitments as much as possible. Platforms are loose frameworks, not bounded substances; they are traversable, permeable and responsive, constituted by their feedback or "dialogue" with an

outside. Just as no single TV show or pop song is as hot today as the TiVo boxes and iPods that manage their organization, so too with art it's the ease and agility of access and navigation through and across data fields, sites and projects that takes precedence over any singular, lone objet.

We increasingly live in a world not of bound objects or fields but of loose networks and data platforms. This is supposed to be a good thing. Networks are said to be inherently democratic and egalitarian, this because of their horizontal, multidirectional and reciprocal capacity, the fact that, compared to more hierarchical forms of organization, in the network it's relatively easy for any one node to communicate with any other. Consequently, the forces governing networks appear more quotidian, immanent and dispersed rather than concentrated in transcendent executive positions. By the same token, the characteristic flexibility and informality of network structures, the way they depend on the constant, relatively independent movement of their participating actors, is taken as evidence of diminished structure and greater agency. Thus along with networks comes a new ideology, one that advertises agency, practice and everyday life, that elevates the pragmatics of doing over the semantics of meaning. It's because of this kind of entrepreneurial and cosmopolitan character or effect of the network that people today can boast of being both insiders and DIY at the same time.

Why do I sound so snotty, what's my problem? Today's stress on practice continues the devaluing of theory ongoing since the late 1980s, itself a political disaster. Celebrating dialogical over monological approaches to art and exhibition can mask the degree to which economic and social control today relies on feedback mechanisms that extinguish every space of privacy in favor of increased just-in-time responsiveness and flexibility. And delusions of agency can obscure the extent of underlying systematic determinants, including the inequalities that evermore structure the field underlying the seeming formal equality of networks. How can this newly emergent mode of artistic agency develop a self-critical component? And how might that critique go? For starters, being part

of a network that privileges itinerancy and circulation over fixity, that diminishes hierarchies and boundaries in favour of mobility across a more open, extensive environment, also subordinates the individual practitioner to a general communicational demand, a decentralizing and integrative logic of interface and commensurability. Networks are both integrative and decentralizing in that they privilege casual or weak ties over formal commitments so as to heighten the possibility of chanced-upon link-ups that lead outward from any one communicational nexus or group. Under such conditions both subjects and objects are obliged to shed not only pretences to autonomy but also long-term loyalties and identifications, and instead to become more mobile, promiscuous operators that mesh seamlessly with the system's mobile, promiscuous operations.

Using this kind of network analysis helps to make sense of exactly what many artists and critics shrug their shoulders over, i.e., today's profusive pluralism, the collapsing of structures that formerly organized collective practice and experience, the decay of canons and critical criteria, the inability to convincingly circumscribe what is most significant about contemporary art within deep historical logics or determinations. Such a collapse is only one side of a simultaneously integrative process, which is the replacement of hierarchical, restrictive and summarizing models of culture, whether spectacular or canonical, with new, more horizontal and networked models based on ever-extending databases and platforms enhanced by better connectivity, a change that has brought with it a new subject, no longer the individual as distilled essence of a centered culture, whether high culture's elitist snob or mass culture's brainwashed couch-potato, but rather a more spread-out and de-centered actor, what sociologists studying this new normative type like to call the "omnivore," or what Gilles Deleuze calls a "dividual," someone who is not a "discontinuous producer" (making discrete objects one at a time) but is "undulatory, in orbit, in a continuous network." Artists who are more "dividualistic" discover themselves not by securing a role within the historical narrative of

a chosen medium but by integrating into a more diffuse ecology that involves not only making art but also putting on shows, publishing and organizing events, teaching, networking, maybe cooking or other services, maybe belonging to one or more semi-collectives, even adopting one or more pseudonyms. It's precisely by falling into disarray and ruin that structures like the museum, the canon, the art world or the art object or artist him or herself become not obsolete but updated, how the spaces of art and culture and even subjectivity become more networked and thus most recently modernized.

One critical question to ask is how do networks, promoted for accommodating such dividualistic free agents, do or don't romanticize the reigning logic of opportunistic exchangeability and the very real dangers of our increasing vulnerability to the moment-to-moment fluctuations of global capital. After all, it was during the mid-1980s that "networking" first became a common buzzword, when networked forms of coordination were appropriated as mainstream business policy, and when neo-entrepreneurialism began to take shape and corporations downsized en masse by eliminating middle-management positions and outsourcing tasks to external spot-labour markets, all the while continuing apace with their mega-mergers and acquisitions. In terms of the workforce, the entrepreneur, free agent and consultant have eclipsed the company man as a labour ideal; while in terms of leisure, the mass consumer has given way to the omnivore and mass customizer. Flexibility, mobility, transience and dialogue— these are no longer challenges to the system, they are the very attributes the dominant system most loudly promotes. Today's resourceful DIY artists risk glamorizing the euphemisms of entrepreneurial initiative and individual responsibility used to sell the recent neo-liberal agenda of deregulation, of rolling back state assistance programs, of "ending welfare as we know it."

It would be hard to concoct a better motto than "do it yourself" for this new age, in which the social contract is increasingly equated with the short-term contract, and the rigid sense of role and identity enforced by disciplinary institutions

are superceded by the improvised adaptations of free agents and their temporary projects within the mobile flux of today's communicational protocols. The syntax of "do it yourself" favours not the spatial matching and mirroring of subject and stable framing predicate but the temporal drumbeat of a verb-centred practice—do, do, do—a practice that is both open-ended (do what?) and oddly autistic (what isn't important, you are), whose second-person subject is posited as the responsive and responsible addressee of an unattributed, generalized grammatical imperative (the address of language per se as the basis of access to social existence), albeit now the imperative implores not just ongoing, intransitive action but the taking of ownership over that action, that commands that the commanded feel themselves in command. The empty index here ("you") is substantiated from one moment of doing to the next, in context after context, by means of a practice with seemingly no other goal than that subject's own perpetual reproduction as self-reflexive. You publish your own blog, run your own gallery, knit your own sweaters. You motivate yourself, apply yourself, manage yourself. Now congratulate yourself! The you in DIY is troubled not only by this claustrophobic autism and treadmill repetition-compulsion but by a founding or ontological contradiction; overly eager to recognize itself in the jingo's open pronoun, it is both authoritative and obedient, its triumph attained only upon submission. And this tension between simultaneous action and reaction continues to mount as the hailing grows louder and more frequent, the jingo becoming a general cultural value, a socially recognized virtue, a political ideal, a normative subject-type. And of course a marketing fad. "'Our,' 'my' and 'your' are consumer empowerment words," notes Manning Field, senior vice president for brand management at Chase Card Services, when explaining the retail trend ignited by the popularity of websites such as MySpace and YouTube. In the wake of collapsing disciplinary arenas—school, family, factory, shopping mall, but also art studio and museum, all frames or "apparatuses" with proscribed, discrete and repeatable practices, the enactment of which leads to their being

identified with as if spontaneously by subjects—instead doing it yourself is today's new generalized, all-purpose call to action, a far more flexible ritual that etches subjects into, carves them out of, neo-liberal ideology.

You being you, a non-artist artist, a dividualistic artist, an artist who defies labels, who doesn't make typical art, who's uncategorizable and nomadic, a hacker of culture and a poet of the everyday, you're a romantic, your template is the romantic hero's transcendent quest of leaving behind common social definitions and roles in search of unique paths and triumphs, fuller truths and a more authentic and rich existence. Definitely we need more effective forms of defiance; I don't question that. But we need less romanticism. Otherwise we look past the fact that our sense of expanded agency today has been purchased largely through an aggressive dismantling and ongoing collapse of the larger social structure. Falling progressively into ruin, that structure now belongs not to romance but to tragedy.

2.0

EMPATHY IS A TOOL FOR MAKING
THE CRUELTY MORE PRECISE (ANIMALS, CHILDREN)

Art is for Empathy
EMILY VEY DUKE & COOPER BATTERSBY

Art is for empathy, and empathy is for the reduction of suffering. That's the way we've always justified being artists. Otherwise, what's art for? What does it do for humanity?

On the one hand, I feel that the artist has a responsibility to reduce suffering in an abstract, global sense which encompasses all the citizens of Earth, most of whom, obviously, will never see the artist's work. This responsibility can only be fulfilled through a kind of ripple effect: we worry, we make work that reflects that worry, the work flows outward and some humanizing impact is felt.

On the other hand, I want to address the artist's responsibility to her or his specific local public, to their audience.

I've been teaching art at the university level on and off for the last five years. Every time I meet a new group of students, I ask them to tell me what they think art is. While teaching at a state college in Chicago, the answers I heard were sincere and slightly naïve: art was for beauty, art was for the spirit, art was a way for the viewer to escape.

A few years ago, we were teaching an advanced-level course at a real art school, arguably the best in Canada. I was shocked by the maker-centred nature of the students' responses. Art, they told me, was for personal catharsis. It was self-expression. Above all, art was for fun. Not fun for the audience, but for the maker. Not one student said that art had anything to do with either the satisfaction of the viewer or the greater good. These are highly educated, politically engaged young people (much more, in fact, than my Chicago students). They are also thoughtful, generous and compassionate.

The problem is that the students in art schools, especially at the undergraduate level, are taught the Duchampian

paradigm: It's art if you say it is, and saying something's art when it's not artful is in itself a radical act. They're taught to be suspicious of the beautiful and the interesting, and to follow their quirky whims regardless of their relevance to anyone else. They're also taught (perhaps without ever being explicitly told) that as soon as something is art, it's precious. As a result, art education creates artists who believe that they don't have to try very hard to create something of immeasurable value.

This is no service to the art world. In fact, I think it's why art is suffering such a crisis of irrelevancy to the public at large. The work we're producing is just not good enough to catch the eye of the non-initiated viewer, let alone hold her attention for long enough to make her care. The best we've managed to do is to incense the public with our hungry dogs chained in galleries and our heroic paintings of naked skin-heads and *Piss Christ*. The fuck-you-if-you-don't-get-it attitude is really not helping, nor is the equally popular it-doesn't-matter-if-it-means-anything-to-you-this-is-about-me.

How can we do better?

We can't just roll over into one of the disciplines at whose interstices we stand. We don't make popular culture (and not just because we can't afford to). We don't make philosophy. We don't make public policy. We aren't activists, and we're not counsellors. We are artists. We make art for a huge array of reasons, from the perverse to the utterly banal.

Here are a few things we can do better. We can educate art students to feel empathetic rather than hostile to the viewer. And, we can value the explicitly emotional in art as highly as we value the ambiguously clever.

And, as ludicrous as it may seem, we can advocate for narcissism as a viable road to empathy in art. Benny Nemerofsky Ramsay's videos, for instance, are perhaps the most explicitly narcissistic works we've seen, yet the work opens hearts. The element that joins narcissism and empathy is love, and love is good. Always, everywhere.

Sometimes we feel like a positive shift is taking place in the art world. We feel it when we think about Okwui Enwezor being selected to curate *Documenta XI*, as well as the work

of artists like Miranda July, William Kentridge, Shirin Neshat, Althea Thauberger, Eija-Liisa Ahtila, and so forth.

Despite the almost hegemonic influence of the methods of New Criticism, we believe that the artist's intention is an important part of the work. The idea that we should base our judgments solely on the text, as though it exists in a vacuum, is an outgrowth of the same purist piety that has driven art into its current state of irrelevant insularity. We believe that artworks are inherently social. We have a word for the practice of making objects for one's pleasure only, without consideration of a wider public. That word is "hobby." Cultural production is not a hobby. It's a vocation.

We have entered a new era of artmaking. It is no longer necessary to be a formalist. Instead of approaching art in literal terms and asking what it is, we should be asking what it does. And what it does, at its best, is connect people with threads of feeling. We're not suggesting we abandon formalism, conceptualism, abstraction, structuralism, etc.

We would like to see a move toward empathy. Toward empathy and away from suffering.

Between *Haircuts by Children* and *The Best Sex I Ever Had*

AN INTERVIEW WITH DARREN O'DONNELL
MIKE HOOLBOOM

Mike

Your apartment is smothered with sheets of paper that read: "Health. Health. Health." What's that about?

Darren

It's top secret. It was a project I did with these 14-year-old kids from Parkdale [neighbourhood in Toronto]. Last Christmas I wanted to play with the talk-show format with the kids and shoot it here in my apartment. I proposed to bring in a bunch of adults over Christmas, what do you guys want to talk to them about? That continued a conversation we were having when I asked the kids what concerned them. Their conclusion was that back-stabbing bitches concern them, gossiping internecine bullshit concerns them, so the conversation picked up from there. How can we make a talk show about that? Our conversation quickly turned toward relationships, romance and sexuality, so they drafted questions while I very deliberately lay back. I did not say no to any of their proposals. It finally wound up in a show called *Health* where they queried adults about sex. People like Ulysses Castellanos, Sheila Heti and Amish Morrell were involved. It wasn't very good because everyone was asked the same questions. More or less. But they're getting more comfortable doing it. We're trying to develop it further now.

Mike

Where are the kids from?

Darren

I met them all at Parkdale Public School a bunch of years ago, when our theatre company [Mammalian Diving Reflex] was

the company in residence. Since then we haven't continued to work with the school, but I'm friends with these kids on Facebook. Sanjay got in touch last summer, I hardly knew him, but he wanted to know if I was aware of any singing competitions—*Canadian Idol*, that kind of stuff. I said I didn't know, but "if you want to make a video we could do something." So I hooked up with some of his friends, and the day before we started one of the kids I'd worked with before was waiting for a bus just outside my building, so I invited him along too. It's been running for a year now.

The Metcalf Foundation is funding a three-year youth wing that will create an institutional infrastructure for our youth work. We also got some money from the province to do a learn-how-to-be-a-producer residency at the Gladstone Hotel; it's called Producers of Parkdale. Ten kids will spend a year at the hotel, taking workshops from people who tackle different aspects of event production, from marketing to production management. Then the kids will partner with someone from the hotel, and later they'll shadow an organization that is renting the Gladstone to do an event. These associations will culminate with the kids running their own office in July, and producing their own weekend festival in August 2012.

We're trying to grow the numbers, but the kids are really selfish because they really love the vibe that they have as a group—you remember what it was like when you were a kid—and they don't want us to fuck with it. They don't want us to bring in other kids who they're competitive with, or who might outshine them, or have more charisma or confidence. So we're careful—we want them to do the recruiting, but what they're saying is that they don't want to draw from their neighbourhood, they want us to get kids from across the city who won't bring the history of a shared school. But I want to work with Parkdale kids for the first year, so they might just have to suck it up. They're so territorial about it. I'm really generous with them in some ways—I mean, it's all to benefit me ultimately, but I spend a lot of money on food and workshops and dance lessons, stuff like that. It's all toward them taking over the company, that's the public thing we're saying.

We would eventually like the company to be in the hands of
the cohort of kids we started working with in 2005. It's a
conceptual, artistic joke goal I have, but I'm also serious about
it. I'll be dead anyway, but I just want to make sure
that there's a cohort of kids who will take over the company
when they're in their late 20s. We've been training them since
they were 10.

Mike

Like those post-theatre schools in Poland.

Darren

Exactly. Like Grotowski or Ariane Mnouchkine's Théâtre
du Soleil where they all live together. But I don't want to do
any of that crap. I want to get them on the road. I want to
train them and send them out so they can realize their stuff
and be project coordinators and collaborate with people
elsewhere. The kids are East Asian, Sri Lankan, Indian, Fili-
pino, Vietnamese, Chinese and Tibetan, so we could link
them to different communities.

I'm trying to expose these ten kids to as much of the
arts community as I can. I drag them to everything I go to; it's
a really good way to get free tickets for stuff. I have parties
here and invite them along with my artist friends. I want to
foster the slight but decisive epistemological shift that you
have when the people who write books are people you know. For
me, I'd never met a person who had written a book, I didn't
even know that was possible. I didn't even know I was allowed
to do that. I'm just trying to expose these guys to a bunch of
people who make stuff in case they're curious about making
stuff. And then the non-altruistic part is that I think there's
a market. We've been very successful in our collaborations with
these kids, we can test-case here, then tour and produce the
work elsewhere. They don't travel with the work yet, but I think
the markets that we're in—the theatre festival markets—
would be interested in these particular kids, their identities
and the way they view the world. I think we can get them
on the road soon.

I think the project will foster some kids who won't think that this kind of work is particularly unusual, who will understand relational practice in their bones. One of the things we're trying to do is obliterate the division between art and production.

Mike

I don't understand the difference.

Darren

In theatre it's really obvious when the producer sets up the circumstances and the artist makes the work. The moment the work gets presented it's very clear when the art is happening, as opposed to when the producing is happening. But in something like *Haircuts by Children* (2006)—when is the art moment and when is the producing moment? It's the same. The calls and emails you have to send as the producer are also casting choices—deciding what school you're going to work with determines who will be in the piece. Negotiating with a hair salon means deciding what the set will look like. Traditional production questions become artistic questions because there is no real artistic moment.

Mike

Why did you start working with kids?

Darren

It was a fluke. After 2003, a shift happened. The concerns of the theatre community wasn't a conversation I wanted to be part of. Why? Flip through a Fringe theatre festival program. "Maxwell is a barista who is frustrated in his search for love because of the difficult time he has being an actor." That wasn't interesting or formally challenging. In terms of aesthetic concerns, theatre hasn't really kept pace with visual arts or performance. I wasn't comfortable there.

In 2003, I started hanging around with Jinhan Ko and Jenifer Papararo and they passed me the Nicolas Bourriaud text on relational aesthetics (post-object art), and all of that

stuff was fine and interesting back in the day. It was about art as
partying, or hanging around as art, along with more effortful
forms. Jin and Jen rebranded as the Instant Coffee collective
and hosted events. Their motto was always: "Get Social or Get
Lost." They were trying to bring people together and look at
social relations, but not really very carefully—I mean, they were
all partied up right? They primarily wanted to be hip and that
was the move then, making Liam Gillick-or Rirkrit Tiravanija-
style aesthetics, which is: you have an event in a gallery and
you leave your garbage behind and that's the show. I'd never
encountered that before, and they were fun to be with. The
other thing they did that was really brilliant was creating
opportunities for other artists to work with them while retain-
ing their own identity. In Deleuze talk they managed to put
together assemblages. Everyone helped make something that
was bigger than themselves, but in the end you could leave
with your piece still intact. Like my make-out stuff. They had
a couple of make-out parties that were inspired by a Spin the
Bottle game I did at Louise Bak's Box Salon in 2003.

Mike

I was there that night.

Darren

Were you? Well, that's where it all began. Did we kiss?

Mike

We didn't.

Darren

Too bad. Afterwards, Instant Coffee organized make-out
parties. The funniest place we did it was in Puerto Rico. The
way they wanted to play it was that there was music and you
spin the bottle and whoever it points out becomes your dance
partner. They weren't up for the kissing. Instant Coffee had a
lot of group shows. Emily Hogg would design a kissing fort
out of blankets, Adrian Blackwell would bring his rubber tube
sculpture you could sort of play in, other people would supply

whatever they were making, and then it would dissipate and everybody still had their work. I hung out with them for a couple of years and that made way more sense than doing stuff in the theatre community.

Do you know Gustavo Artigas's *The Rules of the Game* (2000–01)? He rounded up soccer teams from Tijuana and basketball teams from San Diego and had these teams play each other in the same space at the same time. It was a piece that talked about how the two sets of cultures and languages that are Mexico and America might navigate each other. That's what I use as an example when I talk to kids about social practice. I wanted to make projects with young people that were succinct and had that kind of artistic rigour. *Haircuts by Children* (2006) was the answer to that.

Mike

Can you describe it?

Darren

Get a bunch of kids, hire a hair stylist, spend a week training in the rudiments of hair cutting, rent a salon, then pay the kids to work in the salon. We've presented it in theatre fests around the world. It's basic.

Mike

Did that come out of your stint at Parkdale Elementary School?

Darren

Yes, although there was a project that preceded *Haircuts* where we interviewed them about being 10, and then we did a presentation at Buddies about what it meant to be a 10-year-old.

Mike

What did it mean to be "in residence" at this school? Did you have an office there?

Darren

No, we just asked them if we could call ourselves that. It was

another conceptual performance. By saying we're in residence, we committed to working with these kids, and there were a couple of years where that actually worked. The administration was marginally present, whatever we wanted to do was fine, and then after two projects the principal that hooked us up left. When the next principal arrived, I just acted as if we were part of the scenery so he let us stay. But it's tough to work inside a school.

We proposed a bunch of projects that would bring kids at school together with artists in the neighbourhood. We wanted an office, we wanted to be more day-to-day, but there was a lot of resistance, especially from teachers who considered themselves artsy-fartsy. When a bunch of pros arrive, it's a recipe for conflict. We have so much more to offer, and our understandings are more complicated, and we're cool because we're coming from outside. They don't like me. They consider me a danger to the children because the body of my work before that was occasionally sexy or crazy, and there was an *Eye* article that sensationalized my loopiness, and apparently I said "shit" once…these are a couple of things that have been mentioned to me. But I don't bother with them anymore. We organize the kids independent of them now.

Mike

How did you find the kids you wanted to work with?

Darren

Initially we worked with the whole school. There was a video project called *Show and Tell* (2008) where we asked the kids to bring in their favourite object. We spent two weeks video-taping every student, one at a time; it doesn't make for the most interesting video. And then we had smaller projects for grades One, Two and Three. We brought in a bunch of artists that were doing fun, quirky stuff. Sandy Plotnikoff gave them all a budget and took them to the Salvation Army where they bought little things that they rejigged and put into little plastic balls. These were installed in a bubblegum machine so they could each receive an object one of their friends had redesigned.

That was a nice one. Diane Borsato did something about mushrooms and then took them all for mango lassis. Hannah Jickling came on a day when a neighbouring field had been overtaken by dandelions. She got the kids to pick all the dandelions and then laid them down as a kind of living sculpture along the sidewalk. Ulysses Castellanos took them to the Dollarama and gave them each a dollar to buy one thing. Then we all brought the one things back and broke them into as many pieces as we could and tried to reassemble it all as sculpture. The teacher was mad about that. She said, "That's just a bunch of garbage." Zanette Singh helped them make little dolls that we hid in the city for people to discover. We had to pry a few dolls away from kids who didn't want to give them up.

Mike

Tell me about *The Best Sex I Ever Had* (2010).

Darren

That was a response to everybody thinking that all we do is work with kids now. We thought we'd counter that by dealing with old people. What do we want to talk about? Well, what are we not allowed to talk about with kids? Sex. So we have old people talking about sex.

Mike

How did you find them?

Darren

In Toronto we put up posters on the street, and then we approached queer seniors at the 519 Church Street Community Centre and seniors homes, but it was the posters that really worked. We ended up with six people that we liked. After answering the ad, we would sit around and talk about sex and find the most interesting stories. Originally, it was a show based on these stories—a little on the traditional side—now the way we're thinking about it is like a party with interludes. Audiences could hang out with them for a couple of hours, and then interludes would have them talking about sexuality

and aging. One of the queer guys is 80 and has a lover who is 29. What's it like to be in a relationship when you're 80 years old, or to look for relationships?

Mike

Did they tell you things that were surprising?

Darren

I learned that it doesn't matter how old you are as a female, you can always find young people who want to fuck you. They might not want to hold your hand in public, but you can always get laid. Whereas, it's not so easy for men to find opposite-sex relationships. There's not a lot of 29-year-old females trolling for 79-year-old guys.

Mike

Are seniors having a lot of sex?

Darren

Some are. A lot of them came of age around the 1960s and didn't partake of the sexual liberation that the media focused on because most people weren't doing that. Though they tried in various charming ways. There were familiar stories of buying a red light to spice up their sex life, screwing the red light into a bedroom socket. They were trying to figure out the sexual revolution, without really being part of it. I want to focus on that a little bit, but there are ethical problems. I could reframe their testimonies so that audience members understood that most people missed the revolution. But how do you portray aspects of their experience that they might not know you're showing?

A lot of the women only started to enjoy sex in their 40s, 50s, some even as late as their 60s, because they were part of a generation that didn't talk about sex. One of the women still hasn't had an orgasm, so we bought her a vibrator and she's come close, but at age 73 she's scared to let go. They're really youthful in some ways, they're much less experienced than our cohort. And naive and scared. You hear about

STDs spreading in that population and it's true, they're not well informed.

Mike

Will you do more work with seniors?

Darren

Probably. Though working with populations just because they're a certain age is not the best idea. Being older doesn't guarantee interesting stories or insights. The kids thing has been more charged, and the kinds of conflicts you get in with people are richer.

Mike

For instance?

Darren

The Kunsten Festival des Arts in Brussels stages highfalutin theatre by companies who make no capitulation to audience enjoyment at all. We staged an intervention called the *Children's Choice Awards* (2010). We worked with three schools, 50 kids in all, and formed five juries of 10 kids apiece. A great/terrible thing happened when one of the teachers pulled her kids out. She had French-speaking kids who were all white, while the other kids were Dutch-speaking and mostly Muslim. She said we weren't providing adequate pedagogical information, we weren't helping them understand the work. But we didn't understand the fucking work, what were we going to tell them? She was a cool teacher who was finding herself out-cooled by us…we have a bunch of theories. Our local coordinator called all the parents and explained that the school has pulled out but that they were free to continue with the project. The parents asked, "Are the other kids part of the project?" She lied and said, "Yes, they're all participating," so eventually they all continued. Not only did they really love the experience, they had vetoed their teacher. The teacher got mad and started to assign them unprecedented amounts of homework. Stuff like that is really fun and interesting; triggering this kind of

conflict materialized the themes of the project in terms of kids not being listened to, or being allowed to learn. Kids' rights were being stomped on without even being consulted. It highlighted those matters in useful ways.

People ask why I'm working with kids; they assume I'm a pedophile. I have to deal with that a lot.

Mike

What do you tell them?

Darren

I say the kids are a really interesting population because they remain the only identifiable minority who it's legal to discriminate against. Kids give you two options in terms of how you can respond to them. You can stop them from doing what you don't want them to do. You have the option of controlling their body and being an authoritarian, or letting whatever happens happen and being more of an anarchist. They force your hand: either you're an authoritarian or you're an anarchist. There's no other option, and most people choose authority because it's expedient.

We've developed a protocol on how to deal with them based on the United Nations Convention on the Rights of the Child. We wrote a document called "The Mammalian Protocol" that talks about how we deal with children. There are little tricks in it, like if a kid's doing something you don't want them to do, you take responsibility for it and explain its effect on you. Instead of saying, "Don't do that," you might explain, "I'm nervous that you're going to run into traffic." Generally kids will respond and stop the annoying behaviour because they want your respect.

Mike

How do you deal with things like alcohol or drugs?

Darren

The kids we're working with now are drinking but it's no fun to drink with someone like me; they're drinking with peers in

the park and I don't have to deal with that, it's not my problem. They've asked me to buy them booze, but there's too much to lose, we're too public. But they come over here to my place, and I think of them as a gas because they leak into everything, they're a gaseous substance. They've investigated this whole place, I have no secrets from them. They've gone into my closet and found my condoms and blown them up and played with them. They like to stand around the bed and play this game where they inflate a condom and bop it around in the air and if the condom falls the person has to kiss it. Potentially that's risky maybe. I don't know what they're saying that could be overheard by parents, there may be some risks there. But we're not doing anything wrong.

Social Practice, Children and the Possibility of Friendship

DARREN O'DONNELL

The Cultural Turn in the City

Within the realm of cultural policy, the child is seen to be the beneficiary of ameliorative cultural activity intended primarily to empower, engage, fortify or otherwise improve (Baker 2008, Belfiore 2002, Creative City Network 2005). However, considering the heavy emphasis and rhetoric dedicated to the importance of the cultural industries in economic terms, there appears to be little provision in incorporating children and young people as economic actors, only as social benefi-ciaries. Making matters worse is the fact that commitment to the arts in schools across Canada, the U.S. and the U.K. has been dropping, with arts education increasingly relegated to the bottom tier, and parents having to fund-raise to supply arts enrichment to their schools (People for Education 2008). It appears that the Ministry of Education didn't get the memo from the Ministry of Economic Development that we're now in a creative economy.

The Social Turn in Art

The predominant form within this social turn has been vari-ously called "relational aesthetics," "dialogical art," "littoral art," "new genre public art," with consensus seeming to be coalescing around the term "social practice." Charting the movement's progress through the 1990s, French curator and critic Nicolas Bourriaud, in his 1998 book *Relational Aesthetics*, describes the "possibility of a relational art (an art taking as its theoretical horizon the realm of human inter-actions and its social context, rather than the assertion of an independent and private symbolic space), (that) points to a radical upheaval of the aesthetic, cultural and political goals

introduced by modern art." The roots for this upheaval tracing, he claims, to a global generalization of the urban form and "extension of this city model to more or less all cultural phenomena." The encounter becomes primary and being-together a central theme.

British critic and art historian Claire Bishop (2004) responded to Bourriaud with the criticism that, for the most part, the works that he had used as examples were, for all intents and purposes, parties in art galleries and, referencing Chantal Mouffe and Ernesto Laclau's contention that democracy is fundamentally antagonistic, called for social practice art to roll up its sleeves and antagonize for the sake of a healthy civic sphere. Forming a third point in a social practice trinity is Grant Kester, whose 2004 book, *Conversation Pieces*, comes at the question with an emphasis on an ethic borrowed from Habermas' communicative action. Bishop, in a much-discussed exchange in the pages of *Artforum*, the art world's most prestigious publication, vociferously criticized Kester's preferred artworks as resembling social work, which, in the art world is fightin' words:

> In the absence of a commitment to the aesthetic, Kester's position adds up to a familiar summary of the intellectual trends inaugurated by identity politics: respect for the other, recognition of difference, protection of fundamental liberties, and an inflexible mode of political correctness.

Kester's preferred artists include the Austrian collective WochenKlauser, who, among other projects, have triggered a discussion amongst city officials and sex workers that has yielded the development of a hostel and created an itinerary of activities for developmentally disabled adults. This work only retains the moniker art because the artists say it's art and claim that "the formal-aesthetic discussion has run its course. Its myriad self-referential somersaults have become inflationary, and the worship of virtuosi has given way to other qualities." Bourriaud's roster, in contrast, includes such art world

heavyweights as Liam Gillick and Rikrit Tiravanija, who are apt to collaborate with multinational corporations and international curators to create environments in which to simply spend some time, Tiravanija's most famously re-creating his New York apartment in a German gallery and inviting people to drop by. Bishop, on the other hand, favours the controversial Santiago Sierra, who produces a vast body of interventions, the titles often saying it all: *Homeless people paid the equivalent of a meal and one nights accommodation to stare blankly at a wall all day*, *Unemployed people sitting in boxes for 30 days paid minimum wage* and *Workers Who Cannot be Paid, Remunerated to Remain Inside Cardboard Boxes*.

Over the course of the last few years, Bourriaud seems to have left the discussion to Kester and Bishop, who have taken up positions on either end of an ethics-aesthetics duality, wherein the artist who anchors their work in ethically-based socially ameliorative goals is considered to be an instrumentalized dupe, with artists publically disavowing the appellation "community artist," while, at the other end, critics hurl accusations of elitism at those who claim that doing good is simply not good enough. Kester, who decidedly situates himself on the ethics side of the debate, traces the origin of the conflict back to the mid-nineteenth century where artistic autonomy was cleaved from aristocratic and bourgeois patronage and the avant-garde turned to a strategy of shock to disrupt the middle class, who were seen to be complicit with positivist science and market-based social relations. However, the ability to appreciate the incomprehensibility of an avant-gardist shock required an understanding of this difficult art, thereby relegating it to the world of those privileged enough to have the time to get the proper historical bearing. Kim Charnley, in "Dissensus and the politics of collaborative practice" from the journal *Art & the Public Sphere*, 1:1 (2010), sidesteps this duality by pointing out that both Bishop and Kester assume a free space within the institutions of art, though, in truth, there is no such space, the entire world of art rife as it is with current and historical exclusions. Stephen Wright, in a 2006 discussion with French philosopher Jacques Rancière, points out that within

[an] economy which is increasingly based on the harnessing of what used to be art-specific competence—autonomy, creativity, inventiveness, which is exactly how post-Fordist capitalism functions—there is an increasing response from art and art-related practitioners who feel that they don't want art just to be completely ripped off, to attempt to re-inject their competence elsewhere in a substantively different way.

Though the economy, as Wright points out, now functions much like the art world and the art world is filled with entrepreneurs branding themselves 140 characters at a time, the social turn in the arts and the cultural turn in city planning are the logical result of the avant-garde's push throughout the 20th century to fuse art and life, locating culture at centre stage, while at the same time stripping it of the force of cultural capital. Culture becomes free to generate value in its own right, thus

> [o]ne can think of community-based artists working in poor neighborhoods that are poorly served by city services or that are racked by violence and racial conflict as "outsourcers" and suppliers of process that enhance the value of cities. (Yudice 2003)

In the discussion with Wright, Rancière observes that this reinjection of artistic competence under the banner of something that is not-art is still open to being perceived as art—still *is* art, regardless of the artists' hopes and aspirations. Bishop's concern, in the case of artists packing up their easels, taking their competence elsewhere and starting to act and think more like city planners, is how do you know anymore if what you're looking at is *good* art (Bishop 2006).

This displacement of critical categories away from notions of craftsmanship and virtuosity allows for an easier involvement of the nonartist, children and young people, particularly populations who may be marginal to the dominant culture and thus less conversant with the language and

postures of art. Thomas Hirschhorn's monument works stand out as complex engagements with art history, the art world, the locale and its inhabitant. Dedicated to the study of philosophers (Foucault, Bataille and Spinoza), they are situated in public-housing complexes and created collaboratively with the inhabitants. Hirschhorn situates himself within the locale for an extended period of time and, in collaboration with the residents, builds a small but formidable entertainment complex entirely dedicated to his philosopher of choice and encourages the residents of the surrounding apartment blocks to engage with the ideas of the philosopher. His engagement is at odds with a more community-based practice that would attempt to give the locals a chance to dialogue and express whatever they felt like expressing, the content collaboratively discovered.

Criticisms of Hirschhorn's work have tended to fixate on the power and benefit differential between the artist and his collaborators, with the complaint that the value that accrues to Hirschhorn is considerable. The revelation of this fact, however, much like the uncovering of ideological structures, leaves only one of two options: to continue as ethically as possible or to stop. The calculation that then follows is: (regardless of the magnitude of Hirschhorn's benefit) will the local collaborators benefit more from the project's cessation? In most cases, the answer is no; it's better that the event is occurring than if it were to disappear, since there is the understanding that no one is participating against his or her will and everyone is free to walk away at any time. The critics judge Hirschhorn's benefit against an ethic that expects absolute equity, as if anything short of utopia should be abolished.

Bishop claims that Kester "seems perfectly content to allow that a socially collaborative art project could be deemed a success if it works on the level of social intervention even though it founders on the level of art." However, what Bishop misses is that success on the level of social intervention occurs on a very open and complicated terrain where ethics and aesthetics can overlap, if not feed into each other, the ethical aspects fuelling the aesthetic. Bishop's blind spot was revealed in her April 18, 2011, talk presented by the Power Plant, where

she explained the challenges she experienced while doing ethnographic research on the participants in Hirschhorn's monument pieces, her focus being primarily "what they got out of it." Her efforts were confounded, however, when Hirschhorn simply gave her a list of the names of the participants. Some had phone numbers, most didn't, some had moved, and all were difficult to locate. Bishop expressed dismay, throwing her arms up in the air, and claimed that it was a ridiculously challenging task, unaware that she was revealing the locus of Hirschhorn's rigour: the very difficult fact of working with these particular individuals, people who tend to occupy marginal situations. Bishop continued to wander down the wrong path as she itemized the different ways the participants she did find responded to her question as to what they got out of it, a question never asked of "legitimate" collaborators. You don't ask The Edge what he gets out of working with Bono, you ask The Edge about the work that U2 makes together. While, it's true, Hirschhorn and his collaborators occupy very different worlds, there still can be a fair expectation that the collaborators have something to say about their contributions and not just the effects of the work on their lives. It was Bishop who was steadfastly fixated on the ethical.

In another instance, Bishop again revealed that she's simply looking in the wrong place and need only apply new tests in new areas. Showing a slide featuring superstar philosopher Antonio Negri sitting onstage and reading an essay while a group of Surinamese immigrant children ran around behind him, oblivious to the erudite proceedings, Bishop exclaimed in good-humoured bafflement: "I couldn't understand what all of these people were doing together." In that moment, Bishop experiences the kind of response the artistic avant-garde is always looking for: the antagonism of her sensibilities at the hands of Hirschhorn's unlikely social collage. Here we have a kind of confrontation that confounds the art's linguistic and behavioural codes because it also looks a lot like social work: it has a strong ethical component. The ethical component is, in fact, anchoring the very gesture, creating a shock, not at the expense of ethics but *because of it*. Viewed

from both ends of the ethics-aesthetics debate, it's possible to create situations that are beautiful because they are ethical and shocking because they are ethical, thus in turn aesthetic because they are ethical.

Social practice shifts the tests of artistic rigour, if not on top of, then closer to actual situations themselves, the various populations representing themselves in a context that no longer remains under the sway of the art world's commonplace tests. It's wide-open terrain, the moment of dazzle only being able to be located in the ethics, in the very foundation of art as political, at the exclusion or inclusion of populations of people, ideas and opinions. Is this going to change the world? Perhaps not, but it changes the moment and what is the world but a bunch of moments stacked together?

The Changing City as Material

Since the 1989 Convention on the Rights of the Child, children have been engaged with more seriously, their opinions sought and their various cultures and unique ways of being in the world recognized, caught as they are between a view that accords them a certain amount of autonomy and one that regards childhood as a time to be cherished and protected from the realities of life. Public space, in particular, generates an abundance of irrational anxiety. (British author Warwick Cairns offers the cheeky statistic that if you actually wanted your child abducted, you'd have to leave the kid alone on the street for 600,000 years.) Researchers tend to examine the effects this irrational fear has on only the child's physical health, neglecting any notion of social health.

The ameliorative effects of arts programs on youth have been repeatedly established with varying degrees of certainty. (At the very least, no one has claimed that the arts do harm.) What has not been studied, however, are the effects of a long-term engagement with children and young people in a gentrifying area characterized by relatively extreme social differences, the material upon which much social practice art depends. Artistic interventions in such neighborhoods may have a higher chance of success, with the possibility to yield

new, positive and productive social ontologies that are aesthetically satisfying in their adherence to a beautiful ethic of justice.

The first grounding of this involves deploying Miguel Abensour's notion of friendship. Sudbury-based theatre director Laurie McGauley has called friendship "one of the most sublimated and rational human connections, the least likely to inspire romantic idealism," since it "instills a connection in separation, or a tie that knots us together, while preserving the separation between members of a community." A social practice based on generating friendship between adults and children from differing socioeconomic situations—that of the artist who chooses deprivation and the immigrant family who finds themselves struggling as newcomers—has enough of the aesthetic surprise required of those, like Bishop, who require critical antagonism as part of their art, while at the same time addressing city building and neighbourhood-fortifying requirements by starting to restock depleted ideals about neighbourliness and the clichéd but rarely seriously engaged notion that it takes a village to raise a child.

A long-term commitment of friendship to a cohort of children as a social-practice artwork that is highly publicized, comprehensively theorized and designed to share connections, take up the youth in the artistic practices and share some of the mobility that must accrue to today's successful artist could provide a model for neighbourhood cohesion that would have connections to other locales, while remaining utterly committed to the youth and families at home.

Proposal for Possible Research

Performance company Mammalian Diving Reflex has been collaborating with the children of Parkdale, Toronto, since 2005 on over 12 projects and has established connections that can, now that this particular cohort are in their mid-teens, be considered friendships. The stated intention is to foster a relationship with the youth and, eventually, cede the company to them, leaving it for them to run. It's a long-term goal, with mid-term aspirations being to connect the youth within the

cultural circuits and channels that Mammalian has some command over, with the quantitative goal being simply to get the youth jobs within the creative industries. How many youth get employed, how much they make and how long they remain dedicated to the pursuit will be among the evaluative markers we will employ as well as attempting to identify qualitative effects of the intervention on the youth, their families, the community and the company. The intention is to invert the typical trajectory of charity and rather than hook the youth's fortunes to the fate of the company, we have every intention of hooking the fate of the company to the fortunes of the kids.

Conclusion

The confluence of artistic social practice and urban-planning practice offers opportunities for small-scale testing of utopian impulses that, because of modesty in scope and duration, can be examined for efficacy and, if productive, expanded. From the perspective of the art world, necessarily mobilized for its various cultural resources and aura of status, the interventions would require the requisite dazzle factor, which does not preclude an ethical engagement—on the contrary, it's through a surprising application of ethics that an aesthetic is generated. Collaborations with children reveal exciting, generous and ameliorative social ontologies that manifest notions of community that have been relegated to the realm of a dusty nostalgia. Examining networked capitalism for weakness to critique reveals mobility as an imperative that is vulnerable to deconstruction, the immobility of children standing in contrast, while opening the possibility for viewing a commitment to young people as an ethical disavowal of mobility and, in turn, an affirmation of the local, where encounters can trigger friendship and a community not based on particular identities but only on the quality of time spent in the same place, at the same time.

The Lesser Animals

EMILY VEY DUKE & COOPER BATTERSBY

1.

Humans aren't supposed to fall in love with animals. Everybody knows that. But it happens. Sometimes it's a kind of love that's totally acceptable, because it doesn't have a sexual element, like when people fall in love with their dogs. But sometimes it is not acceptable, because it does have a sexual element. And that was how it was with me and Meema.

I had never had an orgasm before Meema. I couldn't. I just couldn't. It just didn't work for me. Me and Meema started to sleep together in the treehouse, and, I mean, it seemed so normal, so progressive. So successful. I was there to study these animals, and this animal was letting me into her, um, interiority in a way that was so exceptional and beautiful.

You know, I saw how sexual they were with one another. I saw the G-G rubbing, I saw the face to face sex, I saw the frequency of sexual contact. Initially it was really painful, but then, um, when me and Meema started sleeping in the same bed, in the treehouse, it was just so comfortable. It worked. It was almost frightening how intuitive she was about my body.

And I started to have orgasms.

And me and Meema learned to talk to one another. And she was smart. She was smarter than me. She understood things that I didn't understand.

We're going to try to tell some of those stories in this movie, and it might seem really fucked up. It might make people feel pushed past what's safe.

Somebody I really love can't tolerate what we're doing. But there are other people who are proud of us—who know how brave this is. And that's who this movie is for.

Hello, Public. This is Meema.

I am speaking to you today using my TruVoice 9000 voice synthesizer, which Farrah gave me.

The pinkies have so many funny characteristics. The instant I think I understand them, they tell me something new.

Today, Farrah (that's my girlfriend) was talking about something called a "pervert." It was really fascinating! A pervert, apparently, is an exceptional kind of human, who wants things that other humans don't want, or who wants ordinary things, but wants them very badly.

These perverts are quite important. They are instrumental in making pinkie rules, and laws, and statutes. The perverts need to be very creative, because there isn't anyone to tell them how to achieve their desires. In fact, these perverts are the most creative and powerful of all the pinkies. It's their responsibility to determine the whole nature of desire!

I must say, I feel a lot of admiration for these perverts.

3.

Excellent news today for Meema (that's me) and Farrah (that's my girlfriend). Apparently, we're perverts!

Very exciting.

Normal pinkies and bonobos don't have sexual touching together, or live together, or be in love with each other.

We were planning our trip to Los Angeles for the Primates International Zoology Conference. We spend a couple of hours every day getting ready for our presentation. We are going to tell all the other pinkies about us being in love together.

I was already excited about the trip, but now I know that we are going to be the most important of all the animals at this entire meeting! I can hardly wait.

It's true that things are harder for us perverts, though. At first, for example, I couldn't stand the way Farrah smelled. I tried to hide it, because I know how sensitive she is, but she could tell. She started to bathe herself constantly, but that

just made it worse. She smelled too sweet, like sweet garbage, and a cloud of biting flies followed her everywhere.

If her smell hadn't changed so dramatically when she was turned on for sex, I don't think we would've made it.

And that's a perfect example of how important the perverts are! Once there was no one to give advice to apes about how to handle the smell of pinkies, and now there's Meema. And for the pinkies, there's Farrah.

But we have a plan: while we do all those things, we're going to keep a record to send to the people in charge of the rules and laws and statutes, and those people will write it all in a manual, and send the manual out to every pinkie who is considering falling in love with a bonobo, or even a chimp or a gorilla. Though there would have to be some changes.

Chimps and gorillas are a bit dangerous.

I am so excited that I'm a pervert. I can't wait to get to the Los Angeles Primates International Zoology Conference so that I can start helping the rest of the pinkies become perverts too!

4.

My name is Peter. I am the groundsman at the preserve where Meema and Farrah live. And I, too, am a pervert. Specifically, a Peeping Tom. I crept about behind them, crouching to watch as they bathed and snogged.

I used my holidays to attend their presentation at the L.A. conference, and found the whole jaunt rather alarming. First off, there were those insane picketers gathered everywhere the girls went. They carried placards and shouted obscenities. I worried for the girls' safety.

But I felt that the two of them had brought it upon themselves! They certainly didn't hide from the press. Their lecture was the best attended event at the conference. Who else was shagging an ape? It's good copy.

In their presentation, they introduced their new project: a political lobby called Perverts United. Their slogan is "Break the Silence, Equality for *All*," with the "All" in italics. If I

weren't stalking them, I would let them know that Break the Silence is already taken by the domestic violence people.

But here is the problem: I may be a stalker, and I am certainly a pervert, but I won't be throwing my lot in with that bunch. There are sadists among them. Loads. And roofiers and pedophiles.

For the question isn't simply whether one is a pervert or not. There are benevolent perverts and vicious perverts and careless perverts. There are those who are excited by the prospect of maiming the powerless. A minority, I know, but not one I choose to hang about with. I'm just a nice fellow who happens to like following these two about in the bushes.

It is not Meema I blame for this. Farrah is responsible for almost everything Meema understands about human culture, and not because Meema is the lesser ape.

You see, Farrah didn't choose to learn Meema's mother tongue. Meema learned Farrah's.

Who is lesser, then? The perfect pupil or the flawed professor?

It's Farrah. It's us. We are the lesser apes.

5.

Je m'apelle Angel
Et tu t'appelles Angel aussi. oo-oo-oo
Je m'apelle Angel
Et tu t'appelles Angel aussi. oo-oo.

My name is Angel
And your name is Angel too, oo-oo-oo
My name is Angel
And your name is Angel too, too-too.

Je veux enseigner à toi
Beaucoup des choses, oo-oo-oo,
Mais où je peux
Apprendres-les je ne sais pas-pas-pas!
Apprendres-les je ne sais pas-pas!

I would like to
Teach you lots of things, oo-oo-oo,
But where I would
Learn them I do not know-no-no-no!
Learn them I do not know-no-no!

Dialogue Between Animals

JESSIE MOTT

Jackal

Sucker. You possess a terrifying clamminess.

Serval

I can see how she might be repulsed by your slack-jawed,
oily looseness.

Lamb

Okay. I don't deny it. This morning I startled myself awake
with the smell of my own body, how it breeds a twitchy concoc-
tion, a slimy emergency, of sweaty leather and embarrassment.
A skanky oak moss and headache.

 Listen. This cannot be helped. I am nauseated, bubbling.
Slippery with obsessions. She visits in dreams and I wake
up with marks on my body—fizzy eruptions of cauliflower
swellings. An endless parade of blooms.

Serval

Tell us more about these marks.

Lamb

Strange soft shapes, port wine cheeses. Where dirty fishy
accumulations of hairs thrust outwardly in robust sadness.

Impala

Veal baby, I admire the boneless way you navigate the world,
your milky muscled attempts to draw me in. I see you beneath
the fuzz—your two sores for eyes and that dripping smear of
a mouth. You are like a salty reminder, a spongy accident that
prevents me from getting where I am going.

I know that the world comes to you in a series of blurts, a terrorizing mist, a pee smell. I know about your ghost-horse howling. Your knotty, magical operations. I know intimately your tapered neck, your burning head. How you taste like dust and the fat belly of home.

Lamb

A terrible foaminess has come over me. So exhausted have I become, giving birth to her over and over. A beety girl, she receives me adequately, with a mild fervour for what I have to offer.

Once: she slopped against me. We darted our tongues at one another. As hers slipped and bruised against mine, there was an effortless licking and slurping, but feelings were thinning with each jerky movement. She had the body of a plum or some other kind of cruel purpleness. An alarming roundness, was also what could be said about it.

A sticky animal, she slanted inside me somehow with a beast-pining so brutal, it bleached everything white, a chalky tooth-coloured blindness. I almost felt something, almost vegetal, a sediment of a happier time.

Pangolin

This is a private conversation.

There was a time I couldn't find you anywhere; I was looking in all the wrong places. But then I was finally able to say, "…and there you are, dear rodent heart, beating rapidly…" You were wearing a cat mask. And I also said, "Won't you enter into a molecular engagement with me—be me—entirely?" You did not speak. Either you did not feel the urge or you lacked the motor skills necessary to form an adequate response. If I am to be honest, I would say there is coldness about you. But I do miss the forbidding feel of your bones and the complete unfamiliarity of you, the soapy sourness, the downy babyness of you. I fill myself up with the pulpy mass of it. It collects in my mouth, it pools in me.

While listening to you I have vomited four times.

Red Wolf

And I have cut myself.

Vampire Bat

I have thrown myself against the rocks.

Mollusc

Meanwhile, I seem to be farther and farther away from myself. I live something of a life, a small splotch, inside a shell. My membranes have adhered to the inner shell space. You cannot know what it is like so don't bother asking.

Fox

Recently, a moist situation occurred. I know it is about you somehow, your runny face and the general running-togetherness of you. "I'm sorry, it was I who stabbed you," I heard the voice say. Liquids of unknown origin were pooling furiously beneath my flank. Layers of gelatinous flesh, impossible pinks and browns. It was an impalement and, yet, completely removed from spectacle. The blood came slowly, my moaning too soft for sympathy. There is now a numb and dirty sensation that connects the middle to the bottom of me. And yet, the wormy delight of it surprises, shocks.

Snake

I am not afraid to say that I witnessed these actions and from there I derived a gummy satisfaction, a pigeon-coloured happiness.

Rabbit

There is no time left for confessions. I have something to announce. There is something bigger at stake and it is of a dangerous nature. A jelly so red—a cherry, syrupy annihilation—is coming. I am telling you it has velvet and substance. It is wet and there is sagging. There may exist both panic and excitement.

Jackal

A jelly—coming to wipe out the whole thing?

Rabbit

Well—this jelly, it moves faster than you would think. It is not a feeble jelly. It is not "slow as molasses" as they say. It is rapidly approaching. A red you have only dreamed of. A material so thick you would laugh. The scent—that is how it will get you —seduces your animal brain centre.

You are beautiful in the jelly.

Snake

That is alarming.

Deer

That reminds me: I was recently approached by a bloated type, some sissy biscuit face, the limbs too long and too skinny to be of actual use. He had a strange cadence and an unbridled mania, which drew me to the situation. He was the crumbly sort, the kind who might burst into flame or penetrate a melon hole.

Virginia Opossum

I know that waxy ruminant; he is one who sucks everything decent out of life. He drags about in that long body, many compartments.

Once, a very unsatisfying thing occurred. He said, "I see you but I do not know you. You could be a soap or a muffin." I tried to come to terms with this. I needed to know something. I decided to have myself opened up. I wanted to see all the hidden parts, expecting that the internal workings of myself would reveal an array of sparkly bits—scintillating lilac puddings, bouquets of throbbing magenta. But as I lay there, an empty sac, this blubbered spilling situation, I was horrified to find that the inside was a nightmare of beige. What I am talking about here is engorged creams. Unsalted butters, oatmeals, taupes, tans. Even the slime was boring. Do you hear me? These were the organ meats of disappointment.

That must have been painful.

Once, I said, "I cannot sleep, I am plagued with nightmares." A long stalk of something was poking me in the eye. I found this fleshy, unstable character—this problematic circumstance—was inserting himself repeatedly into my cavities. As I woke up choking, gagging, I found that it was not a dream, but you, hissy beaver. You are a thing that probes and tears.

I am a shape.

The Pig's Tail
NELSON HENRICKS

From the first word, I was mesmerized. And I remained so until the end. My friends had told me the book was boring, that the author was too intense—a writer's writer—and was prone to using a broad and complicated vocabulary. But I was completely drawn into the story. I read without counting the pages. I guess this might seem odd to you, given that I am a pig.

I love it when you find an author that you really connect with. You feel that there is a very real and direct communication between you and the writer. This is rare for me: I'm a pretty lazy reader. I usually have a lot of trouble getting into theory or really sophisticated texts. It's difficult for me to know why. I wonder if I have a learning disability or something.

Other pigs I know don't really read. In fact, I think it's safe to say that I am the only pig living openly in human society. You might think that I'd be famous, but I'm not. People don't pay much attention to me. I go about my usual business. Shop on St.-Denis. Go for coffee on Mont-Royal. And to be honest, I enjoy the anonymity. I don't want to be treated like some sort of *cause célèbre* or a freak. I am just an ordinary pig, and aside from a small circle of friends, I like to keep to myself.

In retrospect, I guess my goal was always to integrate. I know there are some people out there who are very critical of the fact I shave myself, but so what? It's not as if I have a lot of hair in the first place, and besides, I like to look as human as possible. It tends to make people less uncomfortable when they are talking to me at parties or whatever. I have had to live through some very excruciating moments. Some people tend to make these very stupid remarks about pigs and, I know, it's the shit thing. People—especially middle-class people—get freaked out because pigs wallow in their own shit. They make

all these mental associations, as if I am unclean or something, just because there are a few pigs out there who wallow in shit.

My circle of friends tends to be made up of fringe types. They're more liberal. Either they think it's hip to hang around with a pig, or they just don't give a fuck. I moved through a lot of social circles since I came to Montréal. Musicians, artists, sex workers, students. Most of my friends now are gay. I like fags. They're bourgeois, but in a marginal way. They wear nice clothes, smell good, have tidy apartments and stuff, but still don't give into all the societal pressure to conform. They have good taste. I've learned a lot about having class since I started hanging out with fags, and that's important to know if you're ever going to move up in the world.

I think I identify with gays for another reason, and again, it's the shit thing. I think ass fucking is what really freaks straight people out—it's the association with shit and dirtiness. But they've got class and style, and that's what I'm into: the contrast.

I've seen other, you know, animals around recently. And by *animals*, I think you know what I mean. I was at this party, and there was this goat there. We never spoke. To be frank, we avoided each other. It was as if we both understood the mutual embarrassment we were causing one another. I looked across the room, out of the corner of my eye, all the while pretending to be deeply engaged in some conversation. This goat was talking to someone, ignoring me, and I did the same, but we were both really hyper-conscious of each other's presence.

Katja called me up about two weeks ago. Told me some friend of hers had a friend who was a sheep. Some accountant from Toronto. Would I be interested in getting together with this guy? "Fuck no," I said, "what the hell do I want to talk to some fucking sheep from Toronto for?" It came out a bit rougher than I expected, and I regretted it later. I didn't want her to know she'd hit a nerve.

My boyfriend's name is Dan. He's a lot younger than me. I think he's 23 or 24 or something. I forget. Everyone tells me he's very

cute, and I guess he is. My friend Katja says he looks a lot like one of the guys from Depeche Mode, if that gives you any idea.

I am trying to think of how to describe Dan to you. Well, he's young and vain, and so he believes that he's indestructible. He drinks way too much and does too many drugs. Now that I think about it, he's a bit of a fuck-up, really. And, to be frank, he's not very bright. But I've never been able to determine whether it is a side effect of the drugs, or something else. Anyway, *il n'est pas un cent watt*, and for some reason that makes fucking him all the more pleasurable. Last night we were at his place and out of the blue he says: "You should get your nipples pierced."

"All of them?"

"Yeah. It would look cool."

"But not terrifically practical. They would get caught on the shag rug and stuff."

"Well, you could just get one done." He seems to lose interest in our conversation here, gets up, and starts rummaging around the room looking for God-knows-what.

"Why are you suddenly obsessed with me getting my nipples pierced?" He doesn't react at first, still pawing through a pile of papers. Then he stops abruptly. The words seem to have travelled across the room in slow-motion. He turns, looks at me hazily with a wide grin and then flops down onto the bed beside me.

"It's really hot. I LOVE my nipples since I got them pierced." Dan is always planning where he will get his next tattoo; which appendage he wants to have a hole punched in. He looks at me and starts rubbing his finger on one of my ears.

"You should get one here."

"On my ear?"

"Yeah, right here. Where it flops over." He suddenly grabs my ear and starts twisting it this way and that, like an artist searching for inspiration. I hate having my body handled in such an impersonal manner. It's anything but sexy, and it gives me the creeps. But then he starts tweaking my nipples one by one between his fingers, and kissing my neck, and pretty soon I am getting hard. I put my hooves on his shoulder,

and begin licking his ears. He's working his way down my chest, licking my nipples with his tongue, and rubbing my dick and balls.

"Stand up," he says. I get on all fours. I can't really see what he's doing so I ask him if he's going to get a condom on. "Uh-huh." He lubes up my asshole and then slides his cock in. Lying on my back while rubbing my stomach with his hands, he fucks me with his slender long dick, moving it in and out faster and faster. My front legs collapse; my ass is in the air.

"Fuck me, you bastard," I growl through clenched teeth. Now he's got a hold of my dick, and is jerking me off as we fuck. My eyes roll back in my head. I am seeing something blue, and then red. "Oh, fuck. You're-good-you're-good-you're…" I ejaculate on the bedspread. Shit. Now I guess I'll have to wash it.

I feel a lot of things for Dan, but love is not one of them.

"What are you writing?"

"Nothing."

I know he sleeps around on me, and who can blame him. He's young. He might as well take advantage of it while he can. He goes out to the clubs a lot.

"I'm going out, OK?"

"OK."

What's odd is I am sure he loves me, but he'd never admit it if I asked him. I know he'd be furious if I slept around on him. He needs to know that I am there: stable and supportive as a set of bookends. We never talk about our feelings for one another.

"It must be weird."

"What?"

"I don't know. Being a pig and being gay, too."

"I'm not gay."

He laughs. "Then what was that all about?" He motions to the bed.

"I don't think you understand. I'm into doing humans. I'm not the one who gets fucked up about gender. That's your problem."

"You'd do it with a chick?"

"Sure I would. Why not?"

"I don't know. I just thought…"

His face curdles with disappointment. I've hurt him. Silence fills the room like a choking fog. I'd better say something.

"Look," I say, getting off my chair and walking over to him, "do you really only fuck me because I'm a guy? You'd fuck a sow in a minute. God damn city kid. Bet you can't even tell the difference."

He looks at me accusingly, his eyes crackling with anger. "The fact you're a guy is what turns me on. I couldn't get it up for a lady pig…"

"Sow…"

"WHATEVER! Your being a guy is important."

"But I'm not gay. And stop yelling. If you want, we can say I'm bisexual. I like doing humans. But that's it."

We sit in silence on the couch for a few more minutes. I put my head in his lap and look up at him. The Cute Cuddly Animal. I know he's a sucker for this routine. He begins stroking my chin.

"Well, I dunno. You might be into…WHATEVER! But I am totally GAY."

"Why don't you fuck me?"

We start to make out. The discussion ends here. We don't discuss his hang-ups. We don't discuss the fact that he fucks animals. What do his parents think? Do they even know? I'm angry with him, but only slightly. I've grown to accept how his mind works. How if he feels he has arrived at one solid conclusion, all other disparities cease to exist. I bite him more than usual tonight, just so he knows he hasn't won.

"OW! That hurt!"

"Mmmm. Sorry."

I once bit a man's thumb off in a bar. Well, that's an exaggeration. Only at the knuckle. He was trying to raise some stink about letting pigs into the bar. Showed that fucker in a hurry. We move from the couch to the bedroom. It's easier on my back.

"How could you put bacon in the salad when you knew he was coming?" The potluck had been relatively uneventful until now.

"Karen, please don't make a fuss about it. It's really not a big deal. There's plenty of other food here for me to eat. I'll be fine."

"I just can't BELIEEEVE it, Cathy. I mean, imagine how you would feel if you went to some party and someone was serving a salad with 'human bits' in it? I'd puke. Literally, I would." She turns to me. "I am SOOO sorry."

"Oh, it's OK. It's fine. Really." I was too embarrassed to tell her that I actually like the taste of bacon. The idea of it revolted me at first. It happened by accident. I ordered this sandwich, it had a little bacon in it, and the next thing I know —BOOM—I'm a cannibal. But I'd feel too weird going down to the dep and buying a whole package of bacon, so I seldom eat it. It's a question of quantity. The idea of a big greasy ham sandwich or a pork roast is enough to make me feel queasy.

"Yeah, I'm sorry," says Cathy. "I didn't realize…I mean, I didn't kind of... I don't know," she lightly smacks her thin white fingers against her forehead, "…THINK! Anyways, DUH! I'm sorry." She smiles. "What's your name anyway?"

"Uh, I don't really *have* a name. People just call me 'pig.'"

"Oh." She looks at me. Her head tilted slightly to the left. A sign of depression? Her straight blond hair cascades over one of her blue eyes. She is chewing at her nail distractedly. She jerks her chin up, brushes her hair from her face with a sudden sweep of her hand. Her eyes scan the room quickly, and then she starts to study the floor. Did she hear me? She says, "It must be weird having no name." I like her. She's young and has this indefinable yet tangible sexiness.

"Not for me, obviously. But it was an enormous hassle getting ID. It took me a long time to get a social insurance number. I don't have a birth certificate. I don't even know what day I was born on."

"I bet you're a Scorpio."

"Gemini. But I was born in the Year of the Pig, if you can appreciate that irony."

She laughs. Her tits are gorgeous. Suddenly Karen reappears.

"Hey, pig, there's someone I'd like you to meet. Robert, this is pig—pig, Robert. Uh, Rob would really like to talk to you. He's helping to organize a conference at McGill about animals. What's it called again? 'Bestiality' or something?"

"'Becoming Animal: Social Perspectives on Bestial Relations.' What we're trying to focus on is how…"

Is he British? He definitely has an accent. Perhaps he's Australian. His thick black glasses are bobbing up and down. I can't quite tell if he's looking at me or not. He's kind of sexy. If you got his glasses off, he'd probably have a very cute face. I love his hair. It's very fine and bushy: reminds me of rabbit fur or something. But he is not very sexual. Not interested in sex. A life of the mind. I should really make an effort to listen to what he's saying.

"…have had confirmation from a number of respected thinkers…"

"Uh-huh."

"…and we're seeking a more balanced representation of…"

I wonder if there will be any money in this? I could use another drink. My mouth feels really dry. I wonder if he smokes. Maybe I can bum a smoke off him. My feet hurt. This is inevitable. I think I have poor circulation. I get so tired, just standing here. Someone else has taken command of this stereo. Thank God. I hate having to listen to that horrible drug-addict music that Dan is always buying—*The Flying Pumpkins* or whatever it is. I wonder if anyone here has a joint?

The conference hall is a surprisingly large. It's a theatre that was designed in the sixties; most likely used for concerts and plays. The interior has been done over in a lot of dark wood, all placed at angles, to enhance the acoustics. The place must seat about a thousand people; it's half full, but that still makes it fairly crowded. I don't think my paper went over all that

well. I'm on stage at the podium under blinding bright lights. People are lining up at the mics placed in the audience, getting ready to ask questions. I've asked someone for a glass of water, but it has yet to materialize.

"This question is addressed to the pig. I was wondering, if this is how you feel about human society, why have you decided to make all this effort to integrate?"

"Well, uh, that's an interesting question. My feeling was—and I am speaking from a purely subjective point of view here—that there was really no future in being an animal. And so, approaching it entirely from a Darwinian perspective, I felt the best thing to do was to move away from the margin, towards the centre."

"But don't you feel that the margins are a place for radical activity? As a location to destabilize the power of the centre?"

"As a theoretical position, yes, I agree with that. But on a practical level, I felt it was far more valuable to think virally. To infiltrate and infect the centre."

A woman suddenly stands up in the crowd.

"You are a fucking sell-out. You are not a real animal anymore. You are just some right-wing conservative, capitalist imitation of an animal. You've betrayed your own identity by co-opting the identity of the oppressor."

A small uproar has erupted in the first two rows of battling nay- and yea-sayers. I'm starting to get nervous. My voice feels tight, like it will break at any moment.

"But," I squeak, "this isn't just about identity. It is about survival. And the ability to survive has always been predicated on one's ability to adapt. To mimic. To camouflage. To develop the proper tools to ensure the propagation of the species. In a human world, the only way to survive is to get with the program."

It's hot underneath the lights. I can't actually see where the voices are coming from. They seem to emerge from a profound and limitless darkness. I'm squinting into the glare. My throat feel incredibly dry and I wish I could have a drink of water. A moment later, everything goes black.

I wake up in the wings, offstage. A circle of people surrounds me. I start in a wave of panic as I abruptly regain consciousness, realizing exactly where I am and what has happened. How long was I out for? What did I say? The organizer of the conference looks down at me, his worried eyes revealing a mixture of concern and shame. He offers me a drink of water from a tall clear glass.

Back at home, my embarrassment gradually ripens into a sulk. I'm lying on the couch with a blanket pulled up over my head. *I will never leave this apartment again*, I vow. I like looking at the folds and creases of the fabric, imagining mountains, sunsets and body parts. I can hear Dan shuffling about the apartment in his slippers. He is in a nurturing mood. It always surprises me when Dan is kind because it seems so contrary to his nature. I hear him put something porcelain down on the coffee table. He lifts up a corner of the blanket cautiously and peers at me with apprehension, as if he expects to be bitten, yelled at, beaten, or worse.

"I made you some soup," he says. The steaming bowl smells good. "Are you hungry?" I don't answer. He sits down beside me and starts rubbing my head. After awhile, I poke my head out and put my chin on his lap. I start eating the soup. It's bland, but I eat without complaint.

We don't speak for a long time. Dan turns on the TV and we begin to watch series of stupid sitcoms. I know that he is curious about what happened at the conference today, but I don't have the energy to recount the whole story. Maybe tomorrow. It feels good just to be here with him. I always come crawling back to him when I am injured.

After two and a half sitcoms, I start thinking about calling Katja to tell her about what happened. It seems funnier the more I think about it. I'll call her in the morning. I should do the laundry tomorrow, too. That bedspread needs washing. Dan senses I am relaxing and, as a consequence, his consoling gestures are becoming more amorous. Soon he is under the

blanket too, kissing me. His tongue is intertwined with mine.
He is rubbing his hands up and down my torso. It is slow,
but good. Slow but good.

The Loneliest Animals
CHRISTINE NEGUS

Where do they put the loneliest animals on Earth? The loneliest animals are kept in the basements of IHOPs. The waitresses, feeling bad, sometimes bring down the plates of pancakes that no one could finish. This makes the animals feel a little better, because for those brief moments they take their attention away from self-loathing.

The waitresses also put some artificial plants from the restaurant in the basement, to make them feel a little closer to their natural habitats. The animals: a turtle, ferret, rhino and a few others. They huddle around the plates, slowly eating the pancakes first, saving the little bits of whipped cream until the end because they like that the best. After, they all pile on top of the rhino to look out the one small "garden" (what the waitresses call it) window to see the outside world.

They see flashes of shoes from families slowly walking to their cars. They see gangs of teens huddled around to smoke. They see the waitresses that come outside together and insult their customers. No one notices them staring, usually no one. Sometimes a child tears away from their mother or father's hand to come to the window but they are quickly rerouted back to the group and quieted for all the nonsense about things in the basement.

And in the evenings, when most of the people are gone, the animals retire to their separate corners. Some of the animals smoke and others cry as they drift off to sleep and dream of water or mountains or forests or sand or about being rushed back to a car with their family waiting in it.

Death Park
MARIA FUSCO

Then just as I go through the big gates at the side of the park, I spy a white plastic patio chair facing a particularly top-heavy oak tree. On closer inspection the chair appears to have been carefully positioned so that its sitter is exactly facing the tree trunk at eye level.

I'm experiencing a strong desire to sit down on the chair, to take in the trunk in detail; the comprehensive glory of its picture plane, scenic cracked bark and parched lichen blooms: general arborescence. But this side of the park is ever so busy, and, to be honest I'll probably get embarrassed if anyone actually notes me studying a tree.

I continue my circuit of the park. There, by the over-flowing litter bin, a mature *Turdus merula* with a Twix wrapper clamped tightly in its beacon-bright orange beak; the gold and red of the wrapper together with the colour of the bird's beak suit each other so well. I wonder if the bird has actually eaten the Twix, or just likes the look of the wrapper. I'd like to see the nest that that Twix wrapper becomes woven into: shiny.

I prefer my nature with a bit of plastic in it. Well defined, open at 7 a.m., closed at 6:30 p.m. Then I know exactly where I am; otherwise I don't understand, nature pushes me out, keeping me at a blade's length. The countryside scares me shitless. Lost, almost but not quite alone, in damp silence, save for legions of little animals that can see you in the dark, circling, with rows of sharp teeth and claws.

A screech. I turn quickly to witness a glossy *Corvus corone* tumbling, the bird falling beak-first from the tree into long grass below. An exaggerated scuffle. A black feathered clump splayed out flat on its back, now extending its wings like a broken umbrella, trying to right itself through a one hundred

and eighty degree rotation. When the bird eventually manages to stand up, it looks very confused and just stands stock-still, blinking for some minutes. Can it remember how it got from the tree's branches to the ground? Was it pushed, or did it forget how to fly?

Twenty-three years ago, walking along Crawford Lane, Mother suddenly and without warning starts thwacking me hard on the crown of my head with a rolled-up newspaper she's unsheathed from her shopping bag. She's spotted a *Vespula vulgaris* crawling into my hair and is trying to kill it. No! Mother might well squash the angry little insect, sting and all, right into my scalp.

I hear my steps, hollow, as I cross the wooden bridge spanning the park's stream to exit. Lately, the weather here has been very muggy, humid and cloudy; the pungent algae which cloaks this stream loves close weather, rapidly coating the water, reeking from edge to edge.

A tiny *Anas platyrhynchos* is emitting the most distressing squealing sound; very loud for something so small, very human for something so obviously not.

I've always wondered why the stench from the algae was so bad; now I think I know. There is a cache of dead baby birds suspended below it, gradually decaying, waiting.

I'm staring; it's so hard to see what is going on exactly. What I can make out is that the algae are stuck to the baby bird's back and wings, weighing it down, pulling it too far down into the stream. Look, the tiny bird's mother is pecking at her baby's back, trying to remove each speck of alga one by one, but she's not helping at all. Rather, with each peck, the smaller bird is sinking further down into the water. The algae seem to be thickening the water, making not only the surface but also the depth below slop around thick and soupy.

The last thing I see is the baby bird going down into the stream and not coming up again.

And now I'm thinking about that incident in Kensington Gardens 12 years ago, when a man murdered his lover and dumped her body into the Italian Garden's ornamental lake. She floated under giant lily pads for three weeks, undiscovered,

until a bird took something from her face, later dropping one flaccid eye near an ice cream van.

"Death Park" originally appeared in *The Mechanical Copula* (Berlin/New York: Sternberg Press, 2010).

3.0

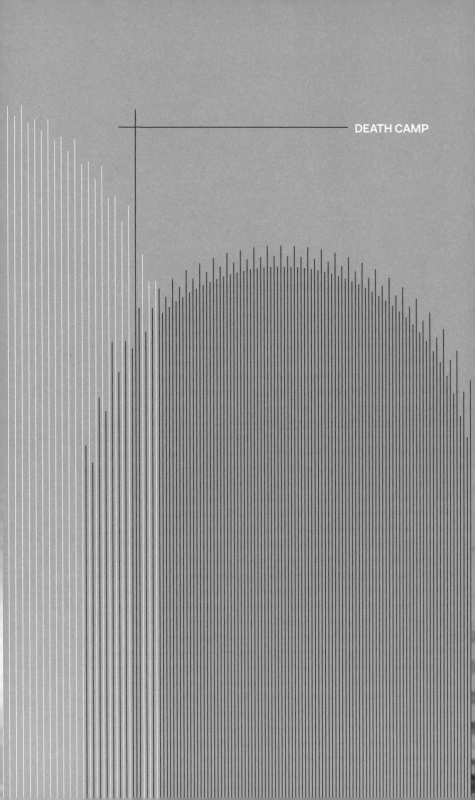

DEATH CAMP

Own Stories

ANDREJ BLATNIK

All these concentration-camp guards, reading books about the meaning of life. About enriching their inner world, about the gift of endless serenity. All these guards, tears coursing down their cheeks at such wonderful realizations while they wait to be relieved. All these guards, hoping that some day— years from now — life will give them an opportunity to write their own stories as well.

"Own Stories" originally appeared in *You Do Understand*. Trans. Tamara Soban. (Champaign: Dalkey Archive Press, 2010).

Death Camp

ELIJAH BURGHER

As a teenager in the 1990s, homosexuality seems to be a death sentence. My constant adolescent erection is a compass leading me to my AIDS-related demise. I gravitate forcefully to the writing of Georges Bataille, the dark music of Coil and Throbbing Gristle. An art teacher in high school gives me a cassette with Bronski Beat and Communards songs. I toss it in the garbage after a single listen. I simply don't want to feel good about it. When I encounter Jean Genet's essay on Alberto Giacometti, in which he posits a unity between same-sex desire and the death drive, I am twenty or twenty-one, and it makes me...*feel good*.

Jean Genet noted a correspondence between homo-sexuality and death. He argued—reactively to the dominant culture's heterosexism, perhaps—that if heterosexuality's object is reproduction, the bringing of new life into the world, then homosexuality is against life, an orientation towards death. It is not difficult to find other examples of artists and thinkers making the same connection: the dystopian romance between the truck-driving rapist-for-hire and his 13-year-old cock-sucking sidekick in Samuel Delany's classic work of transgressive fiction, *Hogg*; Leo Bersani's description in "Is the Rectum a Grave?" of sexually insatiable faggots repetitiously murdering heterosexually constructed masculinity with their endless butt-fucking; the bodies of brown whore-boys, pimps and soldier-johns exploding across war-ravaged landscapes in Pierre Guyotat's *Eden Eden Eden*; and the conflation of sexual and murderous desires in Dennis Cooper's George Myles cycle. Burroughs' ghost looms as well, but he's a whole other story.

In 2004, I receive my MFA, a degree toward which I bear a gloomy sense of irony. Jhon Balance, Coil's singer, has

just passed away. *His* death-drive, expressed as mad lust for alcohol and (by some counts) other mind-altering substances, has driven him over the edge of a banister in his home in England and onto his head, a fall resulting in injuries from which he perishes within hours. I can't stop listening to their first record, *Scatology*. On the cover is a pair of beautiful bare buttocks framed by an inverted cross, an update of Man Ray's *Monument à D.A.F. de Sade*.

That year, I experience bouts of anger at the drop of a hat. Witnessing public demonstrations of Christian faith sends me into a black rage. Even an innocent "God bless you" between strangers on public transportation provokes me. I have an awful fight with a friend about this. Bush Jr. is in office. The cocktail has transformed AIDS into a manageable chronic illness. The president is a sufficient substitute for haunting the social and cultural landscape as a spectre of death and mass-destruction, though.

I am fixated on an Aztec sculpture of the god of death, Mictlantecuhtli. I have not yet seen it in person, although I will in a couple of years. The ceramic sculpture stands as tall as a human, with a large, grinning round head, its dome gridded with holes into which plugs of curly hair had been inserted, representing the chaos of decay into which we all descend eventually. Mictlantecuhtli leans forward, his arms up, bent at the elbows, hands palms-out at chest level. His ass thrusts back like he's about to do a squat or he's begging to get fucked from behind. My close friend Bill will die in three years from a heart attack. He will only be thirty-five. I will become even more obsessed with this particular sculpture after his death, drawing and painting it repeatedly, papering my studio and journals with reproductions.

I begin reading Burroughs in earnest, starting with *The Wild Boys: A Book of the Dead*. Although he and Gysin might have had cubism in mind when they invented the cut-up, I think the method's effects are as much temporal as spatial. The cut-up, in addition to being a teleportation device, is a time machine. It slices up and shuffles two or more discrete pieces of space-time into one another. I fantasize about time machines.

I tell my friends the first place I'd visit would be a coin toss between New York City in the late 1970s and Germany in the 1930s. Burroughs' novels cause me to experience deep sadness for lost time, both moments in my personal past and historical moments to which I'll never have real access. In Burroughs' cut-up novels, memories of St. Louis, comedic routines, paranoid fantasies of intergalactic conspiracy, pederast porno and text appropriated from other sources are ground into word and image dust. Fragments strung together by ellipses or hyphens. The most finely chopped passages are unpleasant, difficult to read. I feel like I am swimming against the blasting current of time, and my subjectivity is coming undone. I'm losing consciousness, I'm dozing off…

The last time I speak with my grandmother before she succumbs finally to cancer, it is in her living room. She knows she is not long for this world, and her parting advice to me is to keep making art and remember to wear condoms. I'm nineteen. It occurs to me afterwards that I'm unsure whether it's AIDS or babies from which she's concerned to protect me. Her death is my first experience of losing someone that I love.

In 2009, I'm invited to participate in AA Bronson and Peter Hobbs' collaborative project, *Invocation of the Queer Spirits*, for its fourth iteration on Governors Island. The séances held by AA and Peter are basically the reverse of Christians attempting to exorcize the demon of homosexuality from some poor fag or dyke. For the project, AA and Peter gather a small group of queer men to a location they've deemed spiritually turbulent, collectively draw the ritual circle, and invite the queer dead to be present and inhabit the space. The participants pass a bottle of whiskey and wear butt plugs adorned with rooster feathers while talking about whatever is on their minds.

I am beside myself with excitement—AA is a hero of mine, and the project is dear to me. It's the sort of thing that I'd thought existed only in my drawings, in my fantasies. After I've taken the ferry to the island, I text AA to let him know I've arrived, and wait for him by the water. I'm so nervous that

I get diarrhea. I'm afraid that I'll shit myself in front of everyone during the ritual. Thankfully, I don't, but I do get a little too drunk that evening, which is typical.

AA and Peter's project posits some deep continuity over many generations, but that continuity is decidedly divorced from heredity, from bloodlines. Queer folks don't constitute a race or nationality, after all. We just happen, like weather, or cancer. I think that the subtext of their project, and the ground of possibility for imagining any kind of queer community amongst the living and the dead, is that patriarchy is an ancient social structure from which we are not yet free. Queer pain runs historically deep. It is ancient.

I have my first real HIV scare. Summer 2010. Stupidly, I hadn't worn protection. I barely knew the guy, and he'd concealed his status from me. I tell my friends that the condom broke. I am too embarrassed to tell the truth. I'm afraid I'll do this again.

When I turn 27, I am single after spending ten years in a series of relationships. I have a lot of sex with a lot of different people. Many of them are complete strangers. I am behaving like a typical urban gay male for the first time. It's fun, I'm good at this, but I can feel time speeding up. I joke with friends that it has to do with the approach of 2012, but I am seriously anxious about the sensation of death being hot on my heels, gnashing its teeth.

I lose a green notebook in 2004 that serves double duty as a sketchbook and a diary. After Jhon Balance dies that same year, a recording of one of Coil's last live shows is released, ...And the Ambulance Died in his Arms. I order it online immediately. On one of the tracks, Jhon Balance speak-sings about losing a green notebook. I decide to experience the coincidence as a sign, although the meaning is unclear to me at the time. Honestly, it still is, but I hang on to the correspondence tightly, like a protective charm. I am beginning to experiment with magic, inspired by Coil, Burroughs and Aleister Crowley's novel *Diary of a Drug Fiend*. My boyfriend at the time tells me that he sometimes feels as if Balance is attempting to possess him while we are having sex. I believe him. I want so badly to

have a conversation with this man I've never met, who I never will meet, who I admire so much.

In my fantasy of taking a time machine to Germany in the thirties, I do not socialize with John Heartfield and Hannah Hoch, but am a teenage *Wandervogel*. I wander the country-side during the warmer months. Perhaps I can play guitar. My hiking club is a communist organization. We perceive the *Hitlerjugend* as our foes. But I abandon my club and join a roving criminal gang. We are not politically affiliated. The newspapers say we are "anti-social." Our imaginations are stuffed with Karl May novels, spilling over with fantasies of the American Wild West and Germany's Teutonic past. We call ourselves the Bloody Scalps, perhaps, or Children of the Rosy Cross. I leave the name Elijah behind and go by Winnetou, or Balder maybe.

In order to join, I must endure a humiliating initiation rite. I am tied upside down to a tree, and our insignia, based on the edelweiss, is cut into my chest with a knife. The dozen other members masturbate in a circle around my suspended, bleeding body, ejaculating on the wound.

We survive by committing acts of petty crime. We are often drunk and bored and amuse ourselves by playing at raping one another like Vikings pillaging small villages. Our violence is a consensual game, but it anticipates the fires that will soon consume Europe. Perhaps, in our ignorance or stupidity, some of us are eventually conscripted into the Brown Shirts. Certainly we are all dead by the time I'm born in 1978.

There is a quick sketch of Mictlantecuhtli in the sketch-book beside me as I write this. I made the drawing last night on the edge of sleep. In the picture, the Aztec god of death, a smiling red skeleton, is standing in profile, his ass thrust out, his claws forward, reaching for me. He towers over me, larger than the actual sculpture in Mexico City. I am facing him, looking up into his ear-wide grin. I have an erection.

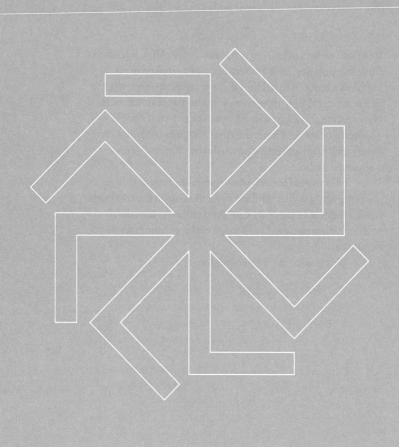

What is the Anal Swastika?

ELIJAH BURGHER

Imagine two swastikas, one overlaid on the other, but tilted forty-five degrees, so that there are eight crooked arms. It conjures a burst of light, the sun, a splayed octopus, the eye of a storm, and a swirling galaxy. It also suggests an anus. Now reverse this eight-armed swastika so that it rotates counter-clockwise. This is the Anal Swastika (AS), eight left hands with razor-pointed elbows, describing the figure of a puckered asshole.

I discovered the AS, which preexisted my finding it, doodling asterisk-like buttholes and musing on the troubling handsomeness of the Nazi's adopted emblem. In order to divine its meaning, I meditated on its contours while masturbating.

This is what the symbol told me:

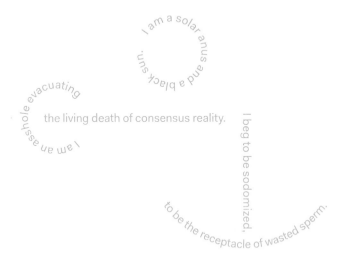

But I will sodomize you in turn,
 and churn your guts like a blender set to "liquefy."

I am a grave into which you stick y y y y
 o o o o
 u u u u
 r r r r

 d f f t
 i i i o
 c n s n
 k g t g
 , e , u
 r e
 s ,

 ,

I am the ditch dug into your backside and
 into which are tossed the murdered bodies
 of your friends and enemies.

I am Orpheus's d i s m e m b e r e d limbs
 thrown to the four corners
 while Maenads submerge his mournful song
 in their shrill wailing.

I am the dark pit into which

 you peered at sixteen, eyes closed, high on LSD,

and glimpsed the outlines of

 your ego,
 your Self,

untangle into a meaningless scribble.

Elijah Burgher

The meaning of the swastika depends on the direction in which it turns. A leftward motion connotes discord rather than harmony with the natural order of the universe. The AS may be likened to a plough tearing up the garden of nature, which is to say nature conceived as a source or mirror of the moral order. In connection to this, it should be noted that same-sex desire has been condemningly labelled "against nature."

Despite the AS's solicitation to sodomy, it is not strictly a gay symbol. Its purpose is not to replace the rainbow flag or pink triangle. Anyway, anal sex can and should be practised by everyone, as should all sexual activities that do not result in the production of new life.

The AS has several applications. It may be utilized to invoke obstacles to be overcome. Test your will in this way, and build intellectual and emotional muscle. Like a witch's ointment, the AS can also be used to induce lycanthropy. Be cautious with transformations unto wildness, however. These spells frequently result in a great deal of collateral damage— to property, friendships, and your physical and mental health.

The AS can additionally be used to recharge the power of various symbols—sigils, logos, flags, etc.—by placing it adjacent to or behind them. In matters both psychic and semiotic, think of it as an engine, an electroshock machine, a defibrillator, alchemical sulfur, the psychoanalyst's couch, or a personal trainer. Embellish a ritual space, a protest, a riot, a speech or other performance with the AS, in order to improve the efficacy of the action undertaken.

Draw it on a small scrap of paper and tuck it beneath your penis, nested on your ball sack, before going out cruising in order to ensure success in the hunt. Dig inside your ass and draw its contours on your prostate gland with your middle finger. Put down the Ram Dass and the Foucault or whatever else you are reading in order to intercede in the shitty-ness of right now and cut it into your skin with a razor. Clench the AS in your mind's eye and allow the centrifugal force of its leftward spinning annihilate the world.

The Gossip and Ghosts of Colin Campbell

JON DAVIES

Viewing gossip … as a form of fabulation allows us to recognize it as a performative mode of oral discourse that produces highly resonant characters, mythic types, or legendary figures whose embodied particularities are the stuff out of which others nourish their hopes and desires for ever more and varied ways of being in the world.[1]

[1] Marc Siegel, "Vaginal Davis's Gospel Truths," *Camera Obscura* 23.1 (2008):156.

Pioneering Canadian artist Colin Campbell (b. 1942 Reston, Manitoba; d. 2001 Toronto, Ontario) used video as a flexible and accessible medium for storytelling; his oeuvre is about characters and their words. Campbell's homespun tapes are a perverse collage of tall tales, rumours, conversations and daydreams gleaned from his everyday life. Ever the great collector, Campbell would borrow a bon mot here, a dirty joke there, a dash of tabloid eccentricity and voilà: an unforgettable story, an unforgettable character. Making art was no sublime act of creation but merely what friends and lovers did together in the incestuous young art community developing in Toronto in the seventies and eighties. Ironic, irreverent and ambiguous, always attuned to the playful shifting of genders and desires, Campbell's tapes chart how identity is performed and circulated in the social world. Boundaries of truth and falsity concerned him even less than conventional ideas of screen acting and narrative closure did; for the most vibrant personas—those we remember and celebrate like his Art Star, the Woman from Malibu and Robin—are those that liberally supplement the banal details of lived experience with the excesses of myth and fantasy.

Art historian Gavin Butt has suggested, "gossiping is a form of social activity which produces and maintains the filiations of artistic community."[2] Campbell's life and art practice derived both inspiration and form through gossip. The characters he created and inhabited—and those he coaxed out of his collaborators— confide secrets and stories to us, crafting elaborate and compelling mythologies around themselves. As Campbell absorbed all manner of talk from his acquaintances, friends and lovers, he and his ragtag troupe of performer-pals processed these day-to-day experiences through video and spat them back out again. This feedback loop opened up his art practice to those of his closest kin as well as to his many students and protégés, resulting in the engaged conversation between artists and artworks that goes into cohering and procreating an art scene.

Gossip is the traffic in unofficial information, a form of makeshift knowledge about people in one's social world and what they get up to. It is not ultimately about whether something is actually true, based as it is on the whims of its participants rather than hard evidence. Campbell's tapes demonstrate how reality can be manipulated and made up to reflect one's desires. Through videotape, he gossiped with and about his real social circle and created a new one, a group of fictional personas who became tangibly real once their tapes were watched, loved (or hated) and talked about. By the time Campbell passed away, his personas were left bereft of a body, but they continue to float freely in our collective consciousness to this day.

So reads my introduction to the exhibition "People Like Us: The Gossip of Colin Campbell," a retrospective of the artist's illustrious video career—the first since his death in 2001—that I curated for Oakville Galleries in Oakville, Ontario, in late 2008. Campbell was an iconic figure in the Toronto art world who was instrumental in establishing the highly visible and vibrant local queer art and media art scenes we have today. The title of my catalogue essay for the exhibition was stolen from his videotape *Culver City Limits* (1977), specifically Campbell's character The Woman from Malibu's haunting

[2] Gavin Butt, *Between You and Me: Queer Disclosures in the New York Art World, 1948–1963* (Durham, NC and London: Duke University Press, 2005), 1.

comment about the man who shot her dead on the highway: "I Did Not Know Him." In my hand, it became a confession: I did not know him, Colin Campbell. But despite this, I was able to get to somehow "know" him—intimately—through his work and through a community that continues to surround Campbell. This collective mantles factual and fictive, living and dead: a chosen family bound together by and invested in the practice of gossip, with its heady potential for fabulation and self-fashioning. Gossip, in this sense, creates community.

What Colin Campbell represented was a kind of permission to self-mythologize. Luis Jacob, both in this volume and elsewhere, has argued that in Toronto in the seventies and eighties, an exciting and glamorous art scene had to be invented out of thin air by Canadian artists—isolated and peripheral to the U.S.—performing what they imagined artists to be, and then seeking out peers, creating or colonizing spaces, and representing themselves in the media. As Jacob puts it, artists had to "perform a scene, perform an audience, in order to summon what does not exist."[3] While Jacob identifies legendary Toronto artist collective General Idea's multifaceted art practice as epitomizing a highly self-conscious performance of "the artist," Campbell, all alone in the even more remote cultural backwater of Sackville, New Brunswick, appropriately enough transformed himself into the imagined persona of an artist, Art Star, in his *Sackville, I'm Yours* (1972).

In General Idea's 1987 text "Towards a World Class Audience," they appraise how the "fictional art scene" they invented through their activities became real as artists flocked to Toronto and organized themselves.[4] They did this through founding artist-run centres (ARCs), our socialized meta-structure for artistic creation and exhibition in Canada that is non-commercial, community-based and artist-led, unlike both the for-profit gallery system and public institutions such as museums. In a text entitled "Art Speaks in the 80s," Campbell lauded progressive and provocative ARCs for encouraging experimentation—including both time-based work, and, I would add, queer representation—and for being dynamic, catholic

[3] Luis Jacob, "From Stream to Golden Stream," *SWITCH* 1.1 (2008): 32.

[4] General Idea, "Towards a World Class Audience," *Toronto: A Play of History* (Toronto: The PowerPlant, 1987), 38-9.

and politically engaged.[5] As he maintained, they were his home, where the action was:

> Public and commercial galleries have notoriously bad reputations as sources of gossip and scandal. In other words, they generate practically none. Almost totally worthless! ARCs, on the other hand, are hotbeds of speculative social philandering…Tongues wag. Fingers wag. Camps are demarcated. Burn out, melt down, flared tempers, dampened spirits…these are the active ingredients of artist-run society. No one's reputation can ever be ruined…we all think we know each other too well. There are no fortunes to be lost, no patrons to shock or offend.[6]

[5] Colin Campbell, "Art Speaks in the 80s," *Parallelogramme* 14.1 (1988): 17.

[6] Ibid.

Campbell's practice was predicated on involvement at all levels of a number of friends, acquaintances and rivals, who both appeared in the work and acted as its audience. As Bruce Ferguson comments in his text "Notes on a Local History," Toronto video artists at the time fulfilled a huge variety of different roles in the scene, and he suggests that "[t]his might return video to its initial, ongoing, historical conception as a tool of community interaction."[7]

Campbell's videos are documents of how his performers chose to perform for the camera in his fictions, while also charting the affiliations and conflicts of his social world. For example, his beloved persona of Robin in his bare-bones diptych *Modern Love* (1978) and *Bad Girls* (1980) left an indelible impression on the Toronto art world psyche by crystallizing all our secret fears about our own social status. Screened in regular installments at the Spadina Avenue musician and artist hangout, the Cabana Room, these videos were explicitly about the Cabana Room and its patrons, and they expertly capture how an art scene functions, its tensions and pretensions, its undeniable allure and the strict divide of insider and outsider. Winningly oblivious to her desperate lack of cool, Robin is the naive girl caught up in a perplexing "modern" world overrun with poseurs and charlatans. Philip Monk, who has studied

[7] Bruce Ferguson, "Notes on a Local History," *Toronto: A Play of History* (Toronto: The Power Plant, 1987), 56.

"Sarah Milroy, "Colin
Campbell: Passionate
Pioneer of Video
Art (Obituary),"
The Globe and Mail,
November 17,
2001, F9.

the self-fashioning and self-representation of Toronto's art scene extensively, has singled out Robin's tapes as a "critical moment in the self-recognition of an art community."[8] I expected that the opening of "People Like Us," which featured *Bad Girls* prominently, would be a similar moment of Toronto art community self-recognition.

Indeed, at the opening, Campbell's community was not only emotionally affected by seeing so many spectres of him in one space several years after his death, but also by the sight of themselves younger, not just from another time but seemingly from another place. The gallery's layout produced uncanny juxtapositions of his and the other faces on his tapes with the faces of those present; sometimes the same person could be glanced both on tape from thirty years ago and live in the flesh as well. Writing about photography, Roland Barthes in *Camera Lucida* finds each image an irreversible reminder that whatever was recorded by the camera no longer exists as it had at that instant. With film and video, the scene unfolds in time— rather than being stuck in a single instant as in photography— but that span of time is still forever gone. All indexical recordings serve to remind us of what has already been lost. Populating the exhibition we have Campbell's ghost, as well as those of Tim Guest, David Buchan, Alex Wilson, Felix Partz, and others who performed in the videos. But separate from the real casualties of history, there are also the fictional ghosts that haunt Campbell's work: several characters continuing to talk, to reveal secrets and to spin yarns for us from beyond the grave. They refuse to let go of their social bonds, as if their need for relationality is so potent that it cannot be stilled by death.

So we have Kerri Kwinter as Anouk, the middle-aged Belgian critic Anna's lover who is dying of cancer in Campbell's masterpiece *Dangling By Their Mouths* (1981). Anouk's death is a devastating trauma that transforms Anna from a charismatic charmer—who beguiles two visiting Canadians, an actor and a performance artist — into a brooding, ominous spectre. While living, she recites a lengthy passage from the dead matriarch Addie Bundren's famed monologue in William Faulkner's

novel *As I Lay Dying*. Kwinter, who chose the selection herself for the video, calls it "the part where [Faulkner] lets his dead woman speak." Then, like Addie, Anouk speaks from the dead herself at the tape's end to offer an unsettling conclusion to the drama.

Then we have Campbell as The Woman from Malibu in *Culver City Limits*, where she devastatingly recounts her own murder on the highway, and as John in *Conundrum Clinique* (1981). Here Campbell plays a vain, cosmetic-keen nuclear scientist whose testimony is juxtaposed with that of Nancy, his boss/lover at NASA, who killed him either accidentally or on purpose during a gay tryst; it's left unclear.

Finally, there's Andrea in *Deadly Destiny*, Campbell's second of two unpublished novels, written in 1998. Appropriately enough, she is a scholar of reincarnation narratives who disappears in Belgium before a conference and writes to her colleague and friend Mallory, the book's protagonist, to tell her how she had been kidnapped and murdered.

These voices from the dead, these ghosts, offer a moving foreshadowing of Campbell's power to stay with us long after his passing, thanks to the proliferation of his body and soul into so many personas and into his intensely loved accomplices over thirty years of work. The gossip of Colin Campbell—his characters and what they said, the real social world they were drawn from—continue to transform the lives of those who saw them. I would like to propose that Campbell's continued presence in Toronto, and specifically in our art scene and its generations of participants, is paradigmatic of a form of queer cultural transmission that transcends frail and fallible human bodies to pass on queer knowledge and feelings across time and space through cultural objects like videos.

The burgeoning field studying queer temporality has opened up the question of how we can imagine different forms of experiencing time, a time outside of the forward-moving rush of progress or the familiar life narrative of birth, childhood, adulthood, marriage, reproduction and death. Queer theorist Elizabeth Freeman has commented on how queers are often constructed as without past or future: on the

⁹ Elizabeth Freeman,
introduction to Queer
Temporalities, *GLQ:
A Journal of Lesbian
and Gay Studies* 13.2-3
(2007):162.

¹⁰ Ibid., 165.

¹¹ Carla Freccero et al.,
"Theorizing Queer
Temporalities:
A Roundtable
Discussion," *GLQ:
A Journal of Lesbian
and Gay Studies*
13.2-3 (2007): 184.

¹² Ibid.,178

one hand, "no childhood, no origin or precedent in nature, no family traditions or legends, and, crucially, no history as a distinct people."⁹ On the other, "no children, no succeeding generations, no meaningful way to contribute to society, no hope, no plans, and nothing to offer most political tomorrows…"¹⁰ The result is that the past haunts many queer cultural producers like a spectre; history compels us. Carla Freccero speaks "of a desire issuing from another time and placing a demand on the present in the form of an ethical imperative."¹¹ In a roundtable on queer temporality in the queer studies journal *GLQ*, historian Carolyn Dinshaw discusses "the possibility of touching across time, collapsing time through affective contact between marginalized people now and then" and suggests "that with such queer historical touches we could form communities across time."¹² These communities that seemingly transcend time and space also include intensely loved cultural objects among their ranks, arguably elevating a work of art to the status of personhood. This is arguably because the closet has historically forced queer visibility away from the social surface to become sublimated into aesthetic expression, with its protective codings of metaphor, subtext and ornament.

In Campbell's two unpublished novels and his final tapes (which date from the mid- to late-nineties), he explicitly grappled with these ideas. In his late videos he returned to the personas he created in the seventies, whether through found footage or through performing them again, and invented new narratives for them. Most poignantly, in *Déjà vu* (1999) Campbell recycles key scenes from the Robin and Woman from Malibu tapes and, through editing, re-imagines them as conversations that took place between these women and their new sister, performance artist "Colleena"—with all played by Campbell. The effect is quite powerful, especially as it transforms what had once been monologues directed at the audience into conversations among sisters, literalizing the relationality that is at the heart of Campbell's oeuvre. These personas all look and sound like Campbell, they share his genes, but in the end they are not him, only fragments of an

ungraspable whole. In Campbell's first novel, *The Lizard's Bite* (1994), there is a character who is given eternal life after finding Caravaggio's diaries, and the painter continues to make mischief hundreds of years later among a group of his fans. The second novel, *Deadly Destiny*, deals with reincarnation and the ripples in the present day caused by a queer Medieval poet and monk on the life of the scholar studying him. Appropriately enough, Freeman has theorized drag as a kind of reincarnation, a historical slippage: "[W]e might think of it as a non-narrative history written with the body, in which the performer channels another body…making this body available to a context unforeseen in its bearer's lived historical moment."[13]

But beyond Campbell's self-reflexive final works, I am more generally interested in his legacy as a way of "retracing," as video artist and academic Nguyen Tan Hoang puts it, "a young person's secretive and circuitous routes to queer culture (through music, art, literature, popular culture) and revisiting the various scenes of queer pedagogy (not only in the classroom and library but also in the park, street, bar, basement, kitchen, chat room, bedroom)."[14] In these scenes of initiation, queer and proto-queer children are transformed by cultural objects and figures from the past that seem to speak through time, and they go on to imitate them in their own lives/artistic practices. The ongoing relevance and circulation of Campbell's identity and his work testifies to the flourishing of an alternative form of community, a queer aesthetic legacy that exceeds the heterosexual kinship/reproductive model. This touch across time and generations is arguably the life-blood of queer cultural production, particularly in the age of our normalization and supposed liberation.

This legacy manifests itself in many ways, from the continued circulation and canonization of Campbell's work to his role as mentor to his videos' openness as texts. Campbell's work is also highly verbal, conversational and discursive, and this flow of talk continues after death because gossip is able to take on a life of its own once it has left a mouth and found an ear. Because they are so intimate and chatty, these tapes give you the sense that you are being let in on a secret and initiated

13 Elizabeth Freeman, introduction to Queer Temporalities, *GLQ: A Journal of Lesbian and Gay Studies* 13.2-3 (2007): 164.

14 Carla Freccero et al., "Theorizing Queer Temporalities: A Roundtable Discussion," *GLQ: A Journal of Lesbian and Gay Studies* 13.2-3 (2007): 183.

into a glamorous club, a social scene that lives longer than individual members do—a community that exceeds time and space. Also, Campbell's characters are mythic. They may originate in daily life but they are supplemented by fantasy to become something bigger: alter-egos that exceed Campbell's authorship.

So Campbell haunts us in a number of ways—he is a ghost—but what is so affecting, I think, is that he is only one of many on the landscape. The ghost has become a privileged figure in queer culture since the dawn of the AIDS pandemic, and these ghosts of the past offer valuable lessons in queer kinship for today. In the queer community, AIDS has effectively eroded the boundaries between the living and the dead, demanding that we make room for ghosts—the ghosts of all those dead artists in particular—and so with AIDS the phenomenon of queer cultural transmission and of artistic legacies being passed on becomes even more a kind of haunting. And I would like to invoke AA Bronson here, who transformed his existence and his art practice after the deaths of his fellow General Idea members Felix Partz and Jorge Zontal.[15] Bronson is now conducting queer séances with collaborator Peter Hobbs and many others that he calls *Invocation of the Queer Spirits*. Bronson states simply: "We each participate in a queer community of the living and the dead."[16] This queer community links past and present, what artist Emily Roysdon refers to as "a queer relationship to history in the movement between time and space." Roysdon continues, "I know that even in my community now, we live in a mythical space…We have had the opportunity to cull our history and in that action we perform our future."[17]

With the futurity of queer community in mind, I would like to return to one of Campbell's most important collaborative relationships, that with filmmaker and video artist John Greyson, whose work is populated by legions of ghosts of history's dead queers. To give just one example, his 1993 feature film *Zero Patience* follows Sir Richard Francis Burton, somehow alive and well and working in a Toronto natural history museum. He hopes to develop an exhibit around Patient Zero,

[15] Nearly thirty years previously, Campbell was the subject of AA Bronson's meta-gossip piece "Truth & Beauty," *File* 3 (1975): 44. Ostensibly about a screening of his work at A Space gallery, Bronson devotes most of his column inches to Peggy Gale's hairdo and reflections on the genius of Vidal Sassoon. Incidentally, when he passed away, Toronto's beloved art-cum-gossip rag *Lola* (1997–2003) smartly featured an imagined conversation between one "Bambi Acconci" and Campbell's personas.

[16] "Interview with Anne Pasternak and AA Bronson," *Creative Time*, http://www.creativetime.org/programs/archive/2008/invocation/interview.html.

[17] Jean Carlomusto, "Radiant Spaces," *Corpus* 4.1 (2006): 78. (Reprinted from *GLQ: A Journal of Lesbian and Gay Studies* 10.4 [2004]: 671–9.)

the mythic promiscuous flight attendant who reputedly single-handedly introduced AIDS to North America. The ghost of Zero returns and Burton, perhaps because he should be dead himself, is the only one who can see him. Greyson's work is so steeped in camp and artifice that one could argue that his modus operandi is anachronism; he collides together seemingly conflicting historical figures, styles and forms in a single work. The figure of the ghost is a literal manifestation of the anachronism, for they are a person who refuses to dematerialize after their time is through. Neither quite dead nor fully alive, they evidence open wounds, unfinished business, moving freely between the past and the present, confronting us against our will. In Greyson's work, if a historical figure could shed light on a contemporary dilemma for the greater benefit of the queer community of the living and the dead[18] then it is our collective responsibility to bring them back to life and squeeze some wit and wisdom from them. So I'd like to think that Campbell's ghost will continue to haunt us as long as we live in a time and place that desperately needs his wryly profound lessons in desire, in how to perform the self, and in how to glamorously navigate a hostile world.

[18] Here I'm invoking the motley crew of Frida Kahlo, Sergei Eisenstein, Dorian Gray, Langston Hughes, Yukio Mishima, Florence Wyle and Frances Loring, who were brought together to talk about washroom sex and its repression in his 1988 feature video *Urinal*.

Originally published in *Public 39: New Communities*, edited by Nina Möntmann.

The Re'Search
(Re'Search Wait'S)

RYAN TRECARTIN

Wait: I love when I'm on vacation. Can someone zip per me up?

O. ♫

_____%‰X_____+_____,

MEOW+

(hold*)* || Ye-he-ha

There zis sa Space where my Heart has Been . . .

Their zis sa SP.ace ware my || Heart has Bend . . .

+

Can us take this higher?

.HIGHER.

re *FEMA HER*

|| Breath

∓

all o o

Get Up getup

Get Up Getup
Get Up Getup

All OO

Come in from the Rain. ||

Demo:　I expect more from technology.

Face e Yeah e ha

March:　Fuck **You**

Demo:　I mean i pour ?Wa**ter**, Back into the **Pool.** +

ASK +

March:　Fuck **Off!**

ifU Wan2Go !FAST

Demo:　*this es es* ?:

I expect **more** + from Technology

..it's **all** right,s : It's *All* WRITE.

Don't Look @meLIKE i'm **not** the post-woman
uTween **you were, u**'stupid Arial !fag.

Retina:　OMG?

Demo:　I can't expect your AGE(group) , to understand my Personality.

Retina:　I'm a **pro**fessional .. **free**'lance .. call me *Retina* ..

Another Tan Variable:

Don't let her talk to you **Retina** .

She'sa_____pool**BOY**

She'sa_____as-whole**BOY**

She'sa_____B'itch hole**BOY**

March:　**You** still play Rule *Role[roll]* :

: **in**[n] - Body Type　　　**!YE.had.AH.**

Demo:　　I'm tot**ally** over **sex!**....*ed*,　　**‰** +

March:　　We're not **blood** rela**ted.**

Demo:　　**&All** that it **functions.**

Yours,

still just **so** playn 'ing **body** .

Look@ that Fuck,**in** *office chair*　,> **?**

Thing you *Need*

Retina: SO!.
I want you to TEL'l me how you **feel,**
And be ¿SO! on point about it.
Do you do Point?

 ¿SO' ?SO!'

*or, is that not a part of your **Person**ality?

+

March: She's a conspiracy flick. She never sticks a'round...
Allways Diving .

Demo: Sounds like some**1** is a control fr**ea**k .?
?Retina , are you a mergin? or just a Staple?.

Retina: I assist in the merging of Structures,
?mentalities, ?souls, ?frameworks,...
Are you two **considering**?

OK. .so *like*. .You're gonna have 2 ,move...
 Actually? U'Know,
If you wanna take your towel off , .?
You can just**B** standing rite'There . .

Retina: huh?

Demo: like¿ God Plexy? , give me the **sledgeh**ammer .?

 (DROP) +

Retina: B⊖Ys, if you tw'oo merged...?
 What **aspects** of your personality would **cancel out**?
 And what would **compro.mise**?

Demo: I,m in2 **Equal Blends** .

March: Demon,str**ate -**

 ah ah ah ah ah

Retina: That's COO**l**

 ah ah ah ah ah

March: A sister collection .

 AH

This is **off device .**

Demo: I want what ever Science is currently Demonstrating.

 ah ah ah ah ah

I'm really young & **post-device**

 ah ah ah ah ah

EverYthing is ,**Just -** In*[n]* Me. +

 i'don't want2 look like an ameba!

 AH

So **don't** prime time, My_____Allways **On.**

U're looking @me like I'm a'thing .

But I'm not *that.%*

Sounds like your POUOLL.SIDE,

 Needs a fuck'ing Heater.

Get a Freak in Heat Her!

Demo: This ?Phone

 A : A,a .

Demo: This '1,2 .

 Get Up

March: Yeah, in*[n]*Side of U .

Re

Demo: My[gayDAD]account is about2 **Jump Start** the next .LEVEL.

Breath

Duet: **EX**perience Whateverything. +

e e e eve

Demo: **thIs'is** !just a .relative body prop

March: U' should bail out ,While'U STILL have function in your LIFE .

Retina: Really?

Demo: Fuck U !Bitch!

March: Sledgehammer

Demo: Fuck !U **B!'itch.**

Retina: I'm not *in two of that*

March: TAP - REEL'ie… Blendy

Retina: If **U** had to rearrange **1** defining **feature**?
What would be theBthe **industry** that would **suffer** the most .
And, explain your **Choice -**

Demo: Fucking pervert server parents,
Buying conceptual vacation crap!

+ + ✚

MASS @ CCed The Pool

March: !Demo?

Demo:

Tel'l my father network

That i am Never c'een.

So I'm just gonna Look@ a VOYrizon of 4ward Thinking

&B_e@,it.

minus U& the Idea of **Communication Comp**anies

the real internet*
Is In*[n]*Side of U

We just need _ .l_LiOf_Ve_E.**+**

*(TRI)

March: I'm going to the **airport!**

Retina: ;) No +

+ !EW **+** !EW
Oh Yeah yAh yAh.

XTAPE

Come in, coming from the Rain.

Demo: &then she Got. Really *cute &emo,tional .

I Got the phones...........

March: I got the Sledgehammer.

Demo: &Then? , She Got_ "Really *cute &EMOtional"

*[really *cute]*...........

March: You're Sooo *cute*, *Retina?

i Told U 'you were ***[cute]*** &emo.tional ...

Demo: I Know ,

Retina: Your *World* .is So .Abstract

ooooooooooooooooo

Can I take *Notes*, and be **apart of it**?...........

ooooooooooooooooo

March: It's Just the ***BED***

Demo: It's ... *just*

Retina: I want'U,2 Look@me? like a Friend would..

¡A **Friend**?¿

Demo: What ,Ever .

March: Switch.

.SWAP¡

Demo: Look@me Like a Friend would.

March: Look@me like a friend would.

Retina: Ina **different .position**?
...*Retina?*
DUET: YES

Retina: What do I say?
..*ooooooooooooooo*
Demo: You're so *[cute]*

Retina: What do I say?

Demo: It's true.
...................................*Retina. a*
March: I like watching her eat. !EAT,

Demo: !Say that to me,

Retina: !EAT,sum-,

Demo: What the fuck r u talking about ?
u fuck in **fag-it** :: u **ass.whole**

Retina: mayBe !Later,

March: maybe later, Sister.

Demo: You're not very good at your fucking job!
My [Place] is SO off point -

Retina: Effort is for people who believe in Consequence.

Demo: I have plans with a different company.

March: yeah

Demo: My eX is **READY**, Feed the Freak In Dog.
Watch me go Alpha-Cuss a Flock of Sibling Geese
inLand it ;)
It's like a Fire Drill,
Next time you see me you better Be Singing,
U !Piece of Shit!

March: What'ever, I'm All Ready in*[n]* House. So it's Really Cheap.
People return4 that **reason**.

?Crap.assk!

DUET: !?Retina, *oo oo oo oo oo*
Take off your **Clothes** .

Retina: _____Their parents, @**VacationHouse**

DUET: !?Retina, *oo oo oo oo oo*
Get Naked.

Retina: _____go, **!Plastic.**

DUET: !?Retina,
Fucking show me your **But't Whole!**
_____**!Plastic.**

!?Retina, *oo oo oo oo oo*
Touch your Thigh.
!?Retina,
Trading Spaces.
!?Retina, *oo oo oo oo oo*
Training Faces. Show me UR **CHODE!**

♮. *L∀st,*

Demo: !What?,

March: I never wanna leave *transition*.

Demo: ¿Si**s**ter. ꟼH**am**mer.

March: Refresh this *Room.* ꓤ

re; ‖ ↻

Demo: Every1 Disappears, I look at the < **clock** > , &it says **11:11**

GeneSi: What? .Ever.,

Demo: Fuck in Double Eve.
 Concise Vacation Journal.

 As'If choosing 2be an *Aquarian* isn't annoying enough. [?]

 ARCHIVE%
 I'm starting to not, *Trust the House.*

March: I'm starting two,

Demo: Laughing

March: not trust ,the house.

March: Fuck in'g Demonstration.
Demo: Decompress, **.bitch**

March: I'm done'(umb), **Echo Walking** your **Epic Cunt**!
Oh Look?! - Not another *Suitcase* .

> 2Bad.
> ,the air port,
> Turned me
> A Way
> .Again #'

GeneSi: What.? Ever.,
Floss: Yack,

Demo: I allways seem'2 start over in this *BED*,
Which is in this *HOUSE*

> That i **D.I.reY-ired**
> To Cover ,symptom.

> I'm me, the *practice space*.
> &I'm mad about it this time.

!Yeah, !Yeah,

Floss: .Yeah.

March: Breaking down our (**father's network**) is Sooo , *DEMO*

!Yeah,

Demo: Get *Ready* to start Angry.
I'm gonna murder ? some fucking ""*father figures*,
As'a com*pressed* !figure.

March: **ummmmm.**

Demo: *Abby* **herStory**?

March: The airport gave me a Free drink coupon.

Demo: Are you my *Literal Lisa*?
Or,r,u .editing a *theme park* behind my Back?

March: So I'm about 40 seconds away from ANthrax

Demo: **Go** March!
Go Go Direction Taker.
Go March!

Floss: ,yeah- i' **kNow**

PHONE: answer ur frick in phone u have a cALL

GeneSi: OMgosh, A specific ultra rock
in my phoneIn **My Phone**.
My Rock just said sumthing!
It's my rock!
The **Giggle** *in my phone* I mean ¿Basically.!?

Floss: I went to a **new surgery office**.
&Now I can *Play* the Flute or **sum'Thing**.

Demo: Yeah DEMOnstrate it.

March: Floss? Play someThing.

Demo: You're a Fuck in Soldier.

?What!

Floss: Check it. Out!

Demo: You're a fucking Crap Face.

?What!

Floss: @Least iDate *People*

Demo: I Like dating myself.

GeneSi: Great.

Demo: i'm **find** with It.

PHONE: answer ur frick in phone u have a cALL

GeneSi: Um Yeah ok.

Demo: Where's that fag it **assk**, ?
Little Mermaid Merger Cunt

Who we was about 2'
recycle video leak on,

Before we looked .
***Contract*?**

Retina: *Over Here!!*♭

₿Retina.infused *(RNI) _{4short} :

I'm Over Hear. M_yother Bedroom!*!*

** reference nutrient intake*

* **Retina(i):** **?**Lets go make sum hot quarter back
 * Cut his dick **off**.
 √⁴/
 &*then*,
 I'll *Kiss* him all over his greasy Face
 &Jam
 A passport up his ass*(k)* ☒

March: *What?*

GeneSi: What is she talking about? Who is She?

Floss: My <u>Flute</u>.

I thought Uwas'a S'inger

Demo: Hey Retina, **Where's my song**?
 I thought you was a **Singer**?

Retina(i): a *song?*.....................................

Floss: I Play the Flute! The *Flute*.

DESK TOPIC

Brandi: **Desk Topic?**

Brucel: ?Brandi, Tell the *World* not to answer **Sammy's Phone.**

Brandi: Your assk is Over, Just make SUM' POPcorn
;& Get in2 Her END'ing.

(Sign**)

JoJo NoBrand: ?Brucel, *The Half Dead Girl,*
Is just an **advertise-mental Gimmick**

Brucel: **Brandi!**

Tell me Science

Brandi: Don't Answer the **Phone.**
DONT ANSWER THE PHONE

JoJo NoBrand: Billboards? or Commercials?
U' can glue a **mall** to my 4HEAD
& i wont C'ee it.
Walk Ever? Just walk a round.
Translator? Come over ,**Here .**

X

WAIT
The Half Dead GIRL

NERD: Sammy-B Just Go with IT!

Do You Need a New Girl Friend?

Sammy-B Never Die: Sammy-B Just Go with IT!
 Well **Don't**
 Look@me.
Don't LOOK@ME!....Um, I'm gonna CALL sum1 .!?

SAMMY-B
Don't LOOK@ME!....Um, I'm gonna CALL sum1 .!?
Hi! . It's Sammy-B
 &if U'r Out there, (?)
 PICK B UP ! B-UP
Don't LOOK@ME!....Um, I'm gonna CALL sum1 .!?
Assist Me. 2Days the Day. Some1 Be's me OFF!
Hopefully, *Sincerely,* XOed OUT!

XOED
This is a Shelf THIS IS A PROP

FUCK UP THE FUCK IN
CALL ME
!YOU ANSWER!

Brandi: This is Me, This is Real.

Pick The F eak **Up The Phon**e

NERD: **Yes.YES.**YES.YES.

TELL **ME**___Causei DoubleBuck &Feelit!

Brucel: **I Love when Sammy-B Feels IT !**
Brandi: This is *Me*.
Brucel: She's SO COOL

JoJo NoBrand: I wanna make This ,**Real** .
 Touch the Screen you stupid POPup!

Brandi: **This is Real**
Brucel: KnoW.!
Brandi: **@Least,**

JoJo NoBrand: I Love my *Translator*,
 She practices my talk in **SIGN** .
 I Pay your **Really well** don't i?
Translator: Yes.?
Brucel: Say her life again.

JoJo NoBrand: **myGUITAR,**
Brandi: This is RE ,
JoJo NoBrand: **myGUITAR,**
Brandi: This is real .
JoJo NoBrand: **myGUITAR,**

Brandi: a lot .

Sammy-B: !Moment this" up to Me!
AH! *ooho*

Check Out, *oooewoo*

the party in my, *oooo*

BEDroom. *oooo*

I'll Fuck in Date-Rape your Boring

RESEARCH

ew wa ewhaaaaaa,

y?'cant, i Stay in? *ew* FOCUS *we*

focus on me,

focus on me *Here.*, *ew wa*

Focus. on Me <u>Here</u>. *ewweww*

Just accelerate my Shit-Head now.

I right myself Checks? *eww eww*

& I don't cash them

Cause you're *Slow*.

FOCUS.on This.!

There's no reason to use any thing that exists

FuckU

aHa

awOOOOO

Allso, Dear, Science?

ahhh hehehehehe

DON'T SAVE MY LIFE BEHIND MY BACK AGAIN

SUCK

suck

My LandScape

MY LANDSCAPE

?thIS?

Listerine

hahahahahahahahahahahaha ew ew ba bay bay be
ew ew ba bay bay be...........................YEah ayh,
It never fuckin'g works

I'm allways just

a Still-Here

(micro).its a wall'k.*(wave)*

Retina(i): I'm thinking, **The World?**

THE WORLD! !♫

YEAH G'IRL

Up where they **Walk**,

ALL BABY

Up where they **Run**,

Up where they **Stay**.

YEAH G'IRL

All day in the **Sun**,

ALL BABY

ALL KnoW

Wondering **FREE**.

YEAH G'IRL

ALL BABY

a OOOOOOOO

W'ish I could **Be**,

Part of your **WORLD**…

YEAH G'IRL

Look@that little mermaid .

ALL kNOw

DUET

Demo: A fuck in duet, DOit,

Retina(i): Do it?

GeneSi: Yeah, 5

Retina(i): Duet, DOit,

GeneSi: Do a Du-et, DOit,

Retina(i): Doit?

They're totally gonna take the solo away from you.

You're Gonna Lose the Solo

And make you join a band.

TRUST
ME

dancing?

DONT_____DUET

Retina(i):Strolling a long on *THE*

Whats that WORD? "again"…

STREET

UP.ware they **Walk.**

UP.ware they **Run.**

UP.ware they Stay all Day in the **SUM.**

Part of Your *whir/*.

Retina(i): *WHOew. WHOew, HA,a,who,ew*

HA,AH,oooWho,ew

Floss: i **TOLD** U.
That was real'e
Soo Goo'od,
You should start a
Band and an&.

.**member.**

Demo: Whatever Biotches.
That was some **wish'full** thinking Shit.

.**SHIT.**

GeneSi: I Loved It.

Demo: As the **Leader** of the **PackAGE**...I'm about to **Force U'ALL**

2[Condense].
.**ALL.**

&.**Start a Band** ann&. fff

Tini: Tini!

Clear: Clear!

Bass: Bass!

ARE YOU OKAY?

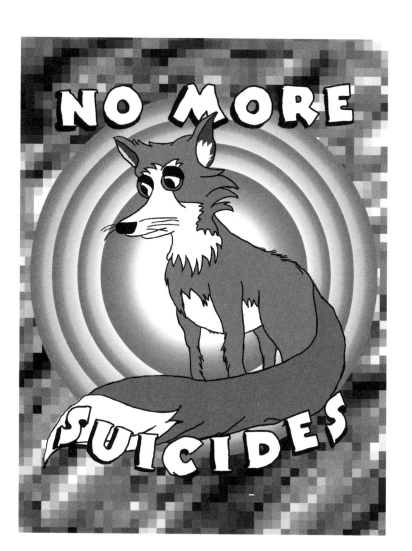

The world is already crowded with instructions—crosswalks, implications, clues. We've projected too much on the moon. Maybe that's why they switched to the stars? The No More Suicide Fox constellation looks astonishingly unadmonishing. His face is sweet and a little sad, as if it was copied from some colouring book from the fifties. Maybe he helps the happy ones go to sleep in their happy beds, no longer needing to make their sad ones promise "I won't, I won't." The children chant, "Star bright, star bright, no one dies tonight," but I'm not convinced. Where is he during the days, the grey days or the ones too bright with sunlight? We need a dog patrol that sniffs out despair and a horde of someones who will ask every single person every single day, "Are you okay?" before another friend is found dead in the bathtub, on the floor. I don't want to talk about that fox. He's pointing at people I know.

This is a book set in the future, so let's dish, let's not wait another moment, what does the future of avant-garde, après-garde movies look like, in this before- and after-garde novel which Dave Eggers, pressed into writing a forward, called "a spaceship with no recognizable components, no rivets or bolts, no entry points, no way to take it apart?" There are too many movies by Himself to describe here, but perhaps I might mention *The Joke*, a black and white, silent, variable-length movie. It is described as "a parody of Hollis Frampton's 'audience-specific events,' two Ikegami EC-35 video cameras in theatre record the 'film's' audience and project the resultant raster onto screen—the theatre audience watching itself watch itself get the obvious 'joke' and become increasingly self-conscious and uncomfortable and hostile supposedly comprises the film's involuted 'anti-narrative' flow. Incandenza's first truly controversial project, Film and Kartridge Kultcher's Sperber credited it with 'unwittingly sounding the death-knell of post-poststructural film in terms of sheer annoyance.'"

And now, for another precision cut, let's return to our moment of time travelling and find ourselves once again in the gossiping furnishings of A Space, where Colin Campbell's four excellent videotapes are being made invisible, even as they are being exhibited. This is not a particularly difficult trick, as it turns out; in fact there is a contemporary industry (or is that too large a word? Perhaps we could name it a trend, an inclination) that is dedicated to this phenomena: it is called the media arts festival. It is called: showing motion pictures in galleries. Most often, most of the time, the work that is on view is rendered invisible, again and again. But let's go back to our intrepid reporter, AA Bronson, as he remarks on that wonderful evening, September 24, 1977.

Sandy Stagg, jagged proprietor of Amelia Earhart Originals, is finding concentration difficult. Like most people at an opening, Sandy is not too intent on the work. Perhaps she came to see who else had come to see who else was there. Her razor-sharp chin swivels right and left, providing the full-profile view that shows

to such advantage Sassoon's most ambitious cut by Sassoon's Toronto director, Mary Lou. The cut is daringly aggressive: a two-layered ledge, dyed blonde and deep red, in steps, like a Chinese pagoda. Sandy Stagg, delighted by this hard-edge confection, has been aggressively promoting this aboriginal vision to her friends and the results are obvious here tonight. The crowd is well-laced with ex-hippies, now splendid in guises of jagged sophistication. Take Isobel Harry, for example. Her hair is an inverted triangle of tight curls, massed with pyramidal precision (it's the Precision Cut) from the base of her flawless neck to the summit of her sensibility.

And now back to Wallace: "the theatre audience watching itself watch itself get the obvious 'joke' and become increasingly self-conscious and uncomfortable..." Unless of course you're getting your hair done, or watching someone else getting their hair done. Is it the discomfort and hostility that makes *The Joke* avant-garde, or do you prefer what AA describes as "the ambitious cut," "the hard-edged confection." Tell me: which avant do you prefer, do you recognize, as your own? At the art opening, the mavens are too busy looking at each other to notice the avant video backdrop. *The Joke* takes this exception as a rule: here the audience is once again confronted with itself, like it or not.

The Joke was followed, in the Year of the Trial-Size-Dove-Bar, by the title track, the last movie ever made by Himself, the fifth version of *Infinite Jest*. It is a movie so fine, so perfect, that it induces a contact addiction; imagine crack cocaine turned into pictures and sounds. Viewers are rendered helpless before its sterling flow, and instantly give up inclinations to do anything else but watch this movie again and again. Did you ever want to make a movie like this? Did I? Between the joke and the jest, we can find two very different approaches to the audience. The jest offers a parody of a maternal mainstream great escapism, this is the avant-garde as *Batman Returns*. Maternal mainstream? Suck on this. And

in *The Joke* we find a more familiar version of the avant world, with its mirror plays and refusals, its cool formalisms and pre-fab design executions. Perhaps you could say, if you were going to get all Freudian about it, that the jest is the mother, the joke is the father. The hot and the cold, the cooked and the raw, suck on this or fuck you.

A google search for the word "avant-garde" brings a not-unexpected result: the top three listings are a hair salon, Wikipedia and a design studio. What is conceptual art, or structural film, after all, but the design studio, experience bent underneath an idea, or at least, the appearance of an idea. The demonstration of an operation, the display of materials interacting, film scientists preparing universal truths, chemists applying universal solutions. It's a dog-eat-dog star man world out there, so I hope you're on my wavelength. Comrades.

Despite the author's protestations that the purpose of writing was to make its readers "become less alone inside," how much of what passes for avant art is the design studio, crisp and clean, the one-liner, the tag line, the sound byte already in place. My title, my sound byte, my art. *24 Hour Psycho, Dancing in Peckham, Erased DeKooning Drawing, Vertical Earth Kilometer, My Bed, The Lights Going On and Off.* Yes, I found the list on Wikipedia, the online multilingual encyclopedia project launched in 2001 by Jimmy Wales and Larry Sanger. Dave Nalle writes, "It has over 10 million articles, about a quarter of which are in English and all of which have been written collaboratively by volunteers from all over the Internet. Almost all of its articles can be edited by anyone, and users collectively police the quality of the content based on a set of consensual rules. The process of editing by consensus can sometimes lead to bias, inconsistency or homogenization of content." Is this the future? Is the avant-garde of information already here, and what may follow, eventually, when they catch up, are the movies? Edited, you know, by the people, for the people, everybody gets to chip in, and everybody gets their share. Like YouTube for instance, though as McLuhan reminded us, back in the sixties, when even poverty and sexism and the oppression of the poor was, you know, glamorous

and sexy and new, new technologies are usually occupied by old forms of expression. Hence the need to turn movies into books. Or at least once upon a time. As Yann Beauvais points out Lev Manovich pointing out, in relation to YouTubing and the internet: "We have a revolutionary new means of content distribution, but…the content tends to remain the same: people write letters, people shoot video, people take photographs."

Infinite Jest is now twelve years old. A pre-teen, then, pre-hormonal. Little wonder that much of the book is set in the Year of the Adult Depend Undergarment, the adult diaper, conjuring a lingering infantilism that is oh so American. Oh so avant-garde.

In his despairing review of the *Whitney Biennial*, *Village Voice* maestro Jim Hoberman, a one-time found-footage-collage-avant-garde filmmaker himself, bemoaned the fact that there was nothing new in these new movies. In a strange and curious turn, he finds himself at the end of his polemic, time-travelling back to his late teens or early 20s, before he had seen and written about and become the authority on thousands and thousands of movies, back when he was still young, back when the movies were still young. There was still a need for the avant-garde then, a need for its sexual possibility, its productive ambiguities, its overly long and far-too-shortness, its obsessive myopias. Now that he has been dragged back into the arena to write "Fear and Trembling at the *Whitney Biennial*," he finds only a reflection of the young man he never was, the hope he no longer holds.

> Underground movies were the political wing of pop art…[b]ut the rise of commercial porn deprived the movement of its greatest novelty, just as midnight movies would usurp the movement's popular base… What was once vital and freewheeling now seems sanctimonious, cliquish, and worst of all, superfluous. The onetime New American Cinema lives in its own peculiar ghetto—a handful of venues…museums, media centres and university film departments across the country—and a state of permanent frustration.

Individuals persevere, but the movement seems 151
moribund. For the average film buff, it's the shadow
of a shadow...

These movies, he insists, belong to a moment of youth-
ful transition and questioning and being lost, and nothing
further. They are a perpetually arrested adolescent dream.
My movies, my self. Is it because I am able to hang onto
moments of my adolescent keenings that I can still, at least
occasionally, find some company and solace in these avant
circles of confusion?

The French call adolescence the age of film-going,
and it may be that the movies you discover then set
your taste forever. Certainly, my own life was altered in
1965, when I began frequenting a cruddy storefront
on St. Marks Place and the even weirder basement of
a midtown skyscraper. I knew movie-movies, but this
was another world: oceanic superimpositions and
crazy editing rhythms, films made from bits of news-
reel and Top 40 songs, "plots" ranging from the creation
of the universe to the sins of the fleshapoids, real
people (often naked) cavorting in mock Arabian palaces
and outer borough garbage dumps.

Can you hear what I hear in Mr. Hoberman's critique?
Can you feel the feint echo? In the Year of the Adult Depend
Undergarment, the adult diaper, conjuring a lingering infantil-
ism that is oh so American. Oh so avant-garde.

Meanwhile, back in our *Infinite Jest*.

How long do you imagine before one of the YouTubers
begins to assemble James Orin Incandenza's filmography,
the eight-and-a-half pages of footnotes offer fair and followable
descriptions after all? Aren't these conceptual bonbons waiting
to be turned into movies, adapted and abbreviated, turned
into motion picture acronyms? Movies do not simply begin with
pitches (or artist statements or grant proposals or footnotes),
they become pitches, artist statements and footnotes. There

they are, sturdy one-liners, particularly at this maximalist moment when there is simply too much on offer, too much on display. Infinity: who has the time for 1,000 pages of infinite jest? Not David Foster Wallace, as it turned out. The writer suffered from depression for nearly twenty years. In the fall of 2008, his partner, Karen Green, came home to find him hanging on the patio of their home in Claremont, California. He was 46 years old. Is it too cold, too awful, too cruel to name this moment between life and death, the decision to make the last decision: could we call this the Precision Cut?

Hollis Frampton writes, "The photograph is a complex cut in space and time." A complex cut, an ambitious cut, a precision cut. What could be more complex or ambitious than a life? We are also making a cut with our words, our habits, our tendencies. Surrounded on all sides, engulfed, drowning in sensations, we hold up the shield of what we still like to call, in a moment of laziness, myself, our selves. I hold up the shield of myself to keep it all from getting up inside me. You are my friend and you are not my friend. Yes, you are my friend, my movie, my ice cream, my avant-garde.

Michael Pietsch, the Little, Brown editor, wrote Wallace that "it's a novel made up out of shards, almost as if the story were something broken that someone is picking up the pieces of." My shield, my personality, my cut, keeps me from this understanding. Five hundred years ago I clung to this word: God, Allah, the prophet, the one whose name can't be spoken. Today I speak of myself. Hollis Frampton again, in a moment from "The Withering Away of the State of the Art": "A few years ago, Jonas Mekas closed a review of a show of videotapes with an aphorism to the effect that film is an art but video is a god." And back to AA Bronson, shuttling between the avant-gardes of the hair salon and the art opening. "A primitive form of television, 'video works like a tape recorder, and like a tape recorder that's been around awhile it accumulates a montage of fragmented conversations, gestures, moments.'" The broken stories of *Infinite Jest*, the fragmented conversations and gestures of video, the broken moments of my life. How I long to lay them all down in a line with a beginning, a middle and,

of course, an end. Please make me a sound byte I can call my own. An epitaph, an epigram, a narrative which will make a whole of all my parts.

Deliver me to the primal scene again, won't you? I want to get married, to myself, in sickness and in health, until death does its part.

No matter that *Infinite Jest* is so damned long, its publisher felt the need to append to it a cheerleading introduction by fellow American avant novelist Dave Eggers. "It's possible, with most contemporary novels, for astute readers, if they are wont, to break it down into its parts, to take it apart as one would a car or Ikea shelving unit. That is, let's say a reader is a sort of mechanic. And let's say this particular reader-mechanic has worked on lots of books, and after a few hundred contemporary novels, the mechanic feels like he can take apart just about any book and put it back together again. That is, the mechanic recognizes the components of modern fiction and can say, for example, I've seen this part before, so I know why it's there and what it does."

I've seen someone like you before. I've fallen in love with someone just like you, before. Here, this is what I said the last time. Here, this is what you said, the last time. This is what we did, this is what we made, together, before we got tired of that too. After a few hundred contemporary love affairs, sometimes with the same person, the love mechanic feels like she or he can take apart just about anyone and put them back together again. But wait. Isn't Eggers describing two very different processes here though? He begins with a reader/mechanic taking apart a book like a car or an Ikea shelving unit. The taking-apart begins, in that small moment of life that exists outside the book, the movie, the avant-garde, in the marginal space between working on the computer and sleeping and feeding and the rest of your sweet short life, the taking-apart begins with I love you. I take you apart with these words. And then I use my hands. I take you apart with my hands. You take me apart with your hands. And then you use the way you talk, the things you say, and most importantly, and most decisively, the things you don't say. It's the things you don't say,

the things you can't tell me, that's what really takes me apart. Eggers is describing two very different processes here. He begins with a reader/mechanic taking apart a book like a car, or an Ikea shelving unit. And then he moves right on and says that the mechanic can put the pieces back together again. But what if you can't? What if you only have the knack, the particular skill, for taking things apart? Please touch me, like this. What if you never learned how to put things back together again? Or much worse than this: what if there is no together? What if there is no originary wholeness, no garden after all to return to, no God to worship, no Devil to blame it all on. What if there are only pieces? "It's a novel made up out of shards, almost as if the story were something broken that someone is picking up the pieces of."

The story and the pieces of the story, are they the same? Do they live in the same breath?

Most of all I don't want to abandon my favourite neurotic stories, the ones I am busy telling myself right now, up inside my head, which is where I still I imagine I live, with seventy-plus kilos of meat acting as a kind of moving pedestal which is walking this voice around, the voice which never tires of rehearsing and replaying my central role in the drama of the world. And then I said. And then I did. And then I wanted. And then I died. The world has basically two parts: there's, you know, the world, and then there's me. And this is the important thing: they're equal. I can hold the world in one hand, and I'm in the other. That's why I get so pissed when everything doesn't run exactly the way I need it to. That's when my friend turns into my enemy, when my ice cream melts away, when my video turns out to be less than God.

The truth is…I'm dying, right now, right in front of you, can't you see that? Can't you help me? I'm dying right in front of you, and you're so far away, caught inside your own voice, your own favourite neurotic stories that you can't help telling about yourself, that you can't help starring in, that you can't help inviting others to guest-star and co-star in, again and again. In other words, out of all this infinity, this infinite jest, you can't help making, like I can't help making, a precision cut.

What I didn't imagine…what they never told me, or if they told me I guess I didn't believe it, I guess I couldn't really hear it after all, is how very lonely this infinity is. Don't you find? I mean this infinity of myself, the way I stretch out far into the horizon, into every horizon that I see and occupy and make my own just by looking at it. And every now and then, when the meat twitches, I might reach out across this horizon of myself and find you there, perfect, and beautiful and lonely, like me, and I'll be opening my hand to your hand, I'll be sharing my interface, my hope above all that your touch will deliver me from the one thing I can't tell myself no matter what, my hope that your hand will also be open and that we might share for just an instant, a breath, a moment of infinite jest. Couldn't we? Couldn't you? Couldn't I? With both hands on the knife, we could make our, we could make our, we could make our precision cut together.

The Five Principles of the PoLAAT

(Post-Living Ante-Action Theater)

MY BARBARIAN

I. Estrangement

Draw a perforated line around your body
Act out the distance between
Yourself and what you're doing
With a line around your body
Adapt the Alienation Effect
Estrangement also incorporates
Elements of camp
And draws a perforated line
Around your body
An ironic displacement or
Disidentification
To critique the action
Represented
The audience it is hoped will be
Similarly engaged
In an active critique of the
Performance
And the questions it poses

II. Indistinction

Contradictory formal and institutional
Distinctions set in oppositional motion.
The performer does two things at once,
Such as singing a love song
And paying taxes.
The play itself refuses to be a play
And becomes a caucus.
Or the narrative explodes
With various plot points

And goes hyper-narrative.
Or the signifiers of pop-music
Are short-circuited by art historical
classification, etc. etc.

III. Suspension of Beliefs
Suspension of beliefs
Suspen-sion
Of beliefs
Of beliefs
Of beliefs

IV. Mandate to Participate
All alone!
I am just 1 person, Together we are 2
In a group! Of 3, 4, 5, 6, 7, There's more that we can do.
All by myself!
I have strength and purpose,
We have that and more
In a group!
Of 8, 9, 10, 11,
Our voice won't be ignored.
In America!
The claim is that each person derives his rights from God
But in America!
Unfair distribution is formalized by Law.
An individual!
Endowed with a body, the rest is arbitrary
It is society!
That authorizes rights, and makes them customary.

It's on us, oh yes, it's all on us.

Participation!
Transparent structures empower all involved
The chaos of our lives!
Must be acknowledged and needs not be resolved
Democracy Now!

A faith in difference and solidarity
Democracy Again!
Collective action toward living parity

Theatre can be a model
For the forms we hope to create
Act out dissent and affirmation
It's our Mandate to Participate, yeah yeah ×2
Each rehearsal's a show,
Each show is a life

Each life's a rehearsal for a better life
If we make each show better than the show we expect
Then our lives will get respect

C'mon! ×8

Theatre can be a model
For the forms we hope to create
Act out dissent and affirmation
Reconfigure the event as a process
Invert the hierarchical stage
The audience becomes the cast
The cast gets naked
Come on!
Mandate to Participate, yeah yeah ×2
Each rehearsal's a show Each show is a life
Each life's a rehearsal for a better life
If we make each show better than the show we expect
Then our lives will get respect

V. Inspirational Critique
Don't tear me down
Why don't you give me somethin' helpful I can work with
Instead of talkin' shit and makin' mean expressions

(Negative scene)

Don't tear me down
And I won't make you feel bad to make myself feel good
I'll give you somethin' you can use to make improvements
Help me grow and I'll return the favour
Face me criticality but full of positivity

(Positive scene)

If we're open about it
When institutional thought is ruptured
An inspirational critique can result
A moment in which, for a second, all is questioned
Allowing understanding of the situation
That opens itself to new possibilities

La la la la La la la la la la la la la la la la la la la La la la la la la la
la la la la La la la la la la la la la la la la la

Do you really wanna leave me this way, brotha?
Crawlin' on the floor,
Lookin' for a hidden door
To get out, sista?

Do you really wanna leave me this way, cousin?
Lost among the trees,

Won't ya help me please
Find my path, nephew?

Do you really wanna leave me this way, teacher?
Lost among the books,
Scrutinizin' looks Lead me to what, neighbour?

Do you really wanna leave me this way, lover?
Stranded on a beach,
You stand out of reach
Give me a hand, honey?

Do you really wanna leave me this way, mama?
Nowhere else to go,
Everybody knows I could love you

(I could love you) Try not to be dismissive
(I could love you) Try not to patronize
(I could love you) Try not to be defensive
(I could love you) Try to sympathize
(I could love you) Try not to be solipsistic
(I could love you) Try not to hystericize
(I could love you) Try not to be overly-simplistic
Try to realize – I could love you!

Employing My Double

ERIN LELAND

Margaret was her name. She replied to my classified for a body
double on a volunteer basis. She did these doubles kinds
of things all the time. She included some photographs with
her measurements, a picture of herself at a comic book
convention and two headshots. During the day she was an
administrator. She was bigger in the bust than me and darker
all around. I dyed my hair at home but the dye went wrong.
Charlie liked this, calling it Goth. Her skin colour was more
yellow than mine. My eyes permanently almond. She was not
so easy to be.
No one else had responded to my advertisement. This was
part of a string of classifieds I placed, calling in one for
a noseless person and in another for a teenager and in another
for a fashion model. She was my only hope as she was a serial
gigist. I had already reserved the wedding shop and it had
closed especially early. The photographer I had hired cheaply
because for him this was practice. The makeup artist specialized
in airbrushing.

Liz, the stylist, only had an hour.

She was late when she came. She was talking about her
husband and dinner and being late. I said that if it was okay
now, I would be made over to look like her and she made
up to fill in the gaps that remained of me.
She had an Elizabethan face that sloped. She wore earrings
with the profile of a queen inlaid.

She had a nose that took off at the tip where mine dropped off.

I had been told that my face was even.

She arrived in work clothes, red plaid skirt and off-colour blazer and sensible knee-length boots and hair in working expression. A medical tag hung around her neck and was engraved, allergic to penicillin and bees. The bell-shaped tag swung away to reveal underneath it a bell-shaped tan line. This bell-shaped tag kept swinging apart from and returning to its negative bell.

We started on the eyes.

The specialist glanced back and forth between her and me to steal her old-makeup feel. She was a skeptic. Was she aware that one of her eyes was more lidded than the other? I had basically no eyebrows and she did. I ended up rather overdrawn. My mouth was most telling because it was more full. The photographer asked whether we should be photographed against a backdrop. This should be done, I agreed, and as a group we pulled the black curtain over the racks.

The specialist wiped my face clean but left hers on and alluded-to long-lasting foundation. Well-named after a Hollywood style.
She was not needed for this next step, only as an example, and so she left to wander.

She was on her way somewhere and I would not have recognized her. She had a normal look. I stopped and watched her go in and it was winter like always and she was dressed completely in black. I could not remember, but I thought that she had lived in the north and not the south and that she worked in the Loop.

She was crossing from the bank into the entrance of the Eighteenth Street station. I too was on the bank side of the street. I recognized her face turned three-quarters as it had been in the wedding shop. And on that day inside this wedding shop there had been Victorian dresses.
She lifted her hand to cough and it had been just that way. The hand long inside the store.

Regrettably, students often arrive at introductory geology classes with the perception that quicksand is an almost malevolent phenomenon that entraps and engulfs the unwary. This misconception rises from the use of quicksand as a convenient plot device in popular fiction. In the fictional context, encounters with quicksand occur in terrains ranging from deserts to swamps, and lead to either the picturesque death of a villain or a dramatic rescue. In reality, the natural occurrence of quicksand is limited to locations where water rises to the land surface, such as swamps, streams, or along beaches. As a threat to life, the density of quicksand is greater than that of water, hence humans are actually more buoyant in quicksand than in water.

Journal of Geoscience, November 1, 2006.

The first was across from the library
In the hallway security mirror
Toilet paper dispenser
the roundabout

White Palace

stormed drain

turnstile

distorted in appliances and passing vehicles
from inside, looking out at night

there in dark photographs

underfoot

word processor page

digital alarm
laminated cover

Architectural Uses of Some Qualities of Music

IRENA KNEZEVIC

Music Is Fire

Behind the Filip Visnjic Elementary School there is a parallel set of residential neo-socialist buildings. The construction has been halted due to the failure of credit systems that funded the development, usually populated by government bureaucracy workers. By 1991, most of the structures kept the promise of Brutalist architecture through the lower-middle-class tenants they housed. The steel beams bled excrement-brown onto the concrete blocks that crept apart from each other allowing for cracks, later separations, eventually carving solid and complete chunks of concrete that fell on the ground around the buildings like gigantic dandruff.

Beyond being another case study of modernist aging and decay, this site had more telling qualities. It was thin due to a stoppage in funding, eighteen identical buildings in a single straight row (very small compared to the 21 block lines of similar developments in New Belgrade (or Novi Beograd), resembling a chessboard with only one row of pawns. On the other side of development was a wasteland ending with an elevation, a hill carrying a Belgrade suburb, Mirjevo, on the river Danube. This wasted space was a physical denial; it was allotted for the rest of the construction, like a placeholder, waiting for the time when the state will fund another 20 rows of buildings. What is important to remember (keep in the imagined map) is that once you left the elementary school and ran through the line of buildings, all you saw was nothing. No trees, some anemic grass, and patches of bare rectangles where boys set up goals for football. Greys, light browns and bleached greens. This was a place for endless fights, running, marble playing, throwing stones, earth as a kitchen, digging,

pets, and in the spring on the first sunny day (very much like today), the Cerga of Romani (band of Romani) would set up tents and fires atop the hill. They brought animals, which attracted us, and children from the other side of the Mirjevo. My school friend Isljam Berisa returned with them and I would play with him seasonally when his family occupied the hill.

In 1991, Berisa arrived with a large dancing bear and a bear cub. Other Romani, like Isljam's father, would travel to the centre of Belgrade in horse carriages with performing animals and earn their living from donations. Their act was the big dancing bear. Regularly, she would just lie on the sidewalk, like an oversized cat, and Isljam's father would pet and feed her. She had no teeth and no claws and as soon as she heard a tune from Isljam's father's harmonica, she would get up on her hind feet, lift one paw and then the other, and dance to the rhythm of the music. It was beautiful, funny and sad, a miracle of cruel sophistication. The children were hypnotized. In 1991, on the hill behind the developments, the mother bear died. They buried her under the marble rolly holes and Isljam's father needed to train the cub how to dance. The little bear studied for two weeks in one of the smaller tents. In the evening, we saw the tent illuminated by warm light, music starting and stopping. It was the same harmonica melody. At first the cub was roaring and crying, drowning the music. We could see the shadows of Isljam's father sitting on a chair playing his harmonica and the bear standing up and down, up and down. We were not allowed in.

Finally, after two weeks the bear was not crying anymore. Isljam and I sneaked up to the tent. We knelt down and found a tear to peek through. Isljam's father was sitting and playing as usual. The bear was in front of him, dancing. Under the bear's feet was a large round metal stool (like a small trampoline) and under it was a steel bleaching pot containing a medium-size fire. The handle of the pot was tied to Isljam's father's leg and he would kick the pot under the bear when he played the music and jerk the pot away when he stopped. The tent reeked of burned hair, flesh and evaporating greasy animal sweat. The metal stool surface was purple from heat, fresh

and charred blood, as the bear's blood boiled and gargled away from feet. The hind paws of the bear left no paw prints, they were raw, but the bear was no longer crying or roaring, just trying to jump away from the heat when the music was playing and cool down when the music stopped. Seeing our terror, Isljam's father told us that this was the last night of training, that the bear feels no pain anymore, and that from now on he will dance to the harmonica knowing through his scars that music is fire.

Music Roulette

During the 2009 NATO bombing campaign, Slobodan Milosevic's official home, Beli Dvor, an eclectic Palladian-type villa built in the 1930s, was not bombed because it housed a Rembrandt painting on the first floor.[1] However, Serbian post-war modernist architectural masterpieces were not spared. One excellent example was the Army Headquarters building on Kneza Milosa Street, designed by Nikola Dubrovic. The building complex (one project) was made up of two staircase-shaped buildings separated by a boulevard. The left building presented a descending form, the lowest stair was street level, and the building on the right was its mirror image, starting from street level to the highest floor being the last staircase. The negative space between the buildings was equal in volume to the sum of both buildings (minus the boulevard width section). Dubrovic himself described his architectural program as "engaged space, analogous to a musical score being played continuously by the listener." A sound.

The ideological core of this architectural program was against literal political narrative, for a new country—Yugoslavia —in need of a non-ethnic style bringing together separate ethnicities into a federation whose members (most of them) had fought against fascism. The architect was to propose an aesthetic of this new national identity. The seeming ambiguity of modernism was a perfect fit.

The 1999 bombing occurred after the atrocities of the 1990s Balkan conflict and formalized with rubble the break that ended Yugoslavia. The Army Headquarters building was one of the first. NATO recontextualized the building as a

[1] If Saddam Hussein did not possess such odd taste in painting (mostly Rowena Morrill fantasy genres involving bikini-clad damsels needing rescuing from monsters and dragons by muscular barbaric men), if he put a Caravaggio in his bunker, maybe his fate could have been different.

Serbian fascist structure, placing the building away from the conditions of its creation, justifying the act through the conditions of its destruction. The balance of positive-negative space was gone, the air won.

The building "retained" an unexploded bomb. The cleanup was too costly and there were no war reparations. The central position of the structure (in the heart of Belgrade) presented a problem. The extraction was impossible and it was decided that knowledge of a bomb that might detonate at any time was too much for the public. The generals decided that the building must bear no sign of danger and should be guarded against intruders non-stop by two soldiers at the gate. This proved inadequate, and after the bombing campaign that number was increased to four men.

In 2002, there were many intrusion problems. Nobody got hurt but this caused worry. After a long meeting, the sub-committee on the issue decided to install a loudspeaker system around the bomb. The system was to blast music at night, at the highest volume, rendering dwelling around the danger area physically impossible for even a deaf person. Their logic was sound. The real issue that took double the time to resolve was which music to play. One general argued that whichever music they played, that music would endanger its fans, since they would not see it as danger but an invitation to party. Nobody could disprove this, so the choice was left to chance: every night the attendant would spin the wheel of the radio (designed to stop randomly) and wherever it would stop, that is what would play that night. Mostly it was white noise.

In 2008, the speaker system was uninstalled after many civil noise complaints as well as a conclusion that the base output of the speaker system might trigger the bomb.

The exterior of the building went through changes parallel to changes taking place on the streets of Belgrade. It stood bare without cover, then it was covered by a tarp, then by Nike ads (as the Serbs cashed in their socialism for another Eastern European satellite capitalist market), and finally the building was bare again, with ads for a fence hiding the ground floor only. This is how it stands today.

> Louis Kahn designed the Salk Center in La Jolla…
> as an eloquent composition that is spatially and
> symbolically incomplete, with its two richly rhythmical
> buildings…[which] define a powerful axis that is open
> at each end and that constitutes thereby a significant
> gesture within an American landscape. The composi-
> tion of this common space…is perceptually, physically,
> poignantly American as it frames the sea and the
> land where the old western frontier ends and the new
> eastern frontier begins.[2]

[2] Robert Venturi, criticizing the proposed expansion of the Salk Institute as a violation of the original plan. (*Iconography and Electronics Upon a Generic Architecture: A View from the Drafting Room*, Cambridge: MIT Press, 1996)

The concrete of the Salk Institute is made with volcanic ash, relying on the ancient Roman concrete-making techniques. As a result, it gives off a warm, pinkish glow. Today, the Salk Institute has been closed off by a tall metal fence as a conse-quence of 9/11, fear of terror attacks and espionage.

It is rumoured (I heard this story from a stranger on the beach under the institute) that down the street from the Salk Institute, UCSD hosts the continuation of a research project whose aim was to design a method to communicate to a wheelchair instructions from a disabled person's brain. The person without the ability to move his/her body thinks the word "right" and the chair goes right. The initial research was done at University of Illinois at Urbana-Champaign, and a larynx control system, called Audeo, had been developed in 2007.

At UCSD, a more serious study is taking place. Its goal is to project an image of enemy terrain into the back of a drone-plane operator's optical nerve and, with the larynx control system, to guide the missile to the appropriate place, then drop the bomb by blinking twice. The men enlisted for this study had to have a family, allowing them to do work at home from a computer until the research provided a breakthrough and the computer system replaced with an implant. Their offices were moved to their homes (secure apartments buildings on bases) to provide a soothing warm environment for the men.

They could play with their kids and then go to the office and drop a bomb on someone else's kids.

This proved disturbing to some men and most returned to the original offices on the military base, where the soothing was done by classical music. Mostly Chopin. When the research concludes, a man somewhere will think "kill" and the bombs will fall. The only other character in the stories of man that thinks death and does death is death itself. And who knew that Death would like Chopin? I always took Death for a Bruckner fan.

withblast
JOERG BECKER & IRENA KNEZEVIC

Let us get nearer to the fire, so that we can
see what we are saying.

The Bubis of Fernando Po

Probably the most generally accepted simulation of independence transpires in the presumption that one's own actions and thoughts are based on one's own decisions. Not that one's actions and thoughts aren't one's own, but when it comes to decisions leading to actions and thoughts, things look different.

Of course, we can do or not do, think or not think what we do or think. But what makes one do or think *this* instead of *that*? More so: what makes one *not* act or think in a certain way?! The answer usually provided seems simple and all too "natural": selection. It is the opportunity to select among alternatives that makes one independent. The basic precondition for uncorrupted selection is different sources and perspectives to choose from: i.e., different values. This mechanism of accumulating *knowledge* by *selection* may be commonly well acquainted. However, it is commonly just as well misconceived. To put our point across, we will reenter this essay and shoplift a predication in Niklas Luhmann's blasting supermarket *The Reality of the Mass Media*…so as to get a bit nearer to the fire.

Whatever we know about our society, or indeed, about the world in which we live, we know through the mass media.

1.

The world presented to us as "natural" is a mediated simulation of our environment. We consider McLuhan's *hot media* a *market* that is operated by all technological means of communication and distribution, spaced throughout and embedded within the entirety of the *capitalist market* (success oriented). We choose the word *market* instead of *mass media*, for inevitably it never arises from the masses. Be our consideration as it may, there's nothing "natural" in being an object of a mediated simulation system.

2.

The 21st century's purpose emerges in the early wave of *Cybernetics* and, concomitantly, *Systems Theory. Cybernetics* was defined by Norbert Wiener in 1948 as "the science of control and communication, in the animal and in the machine." W. Ross Ashby added in 1956, "[It is] the *ART* of steermanship...." Both *Cybernetics* (of the first order) and *Systems Theory* provide the foundation of contemporary science, warfare, internet, sociology, art, design, architecture, marketing... etc. It is a sign of their reach that these ideas have established terms like "target group" in everyday language. This is the world we are driven by. It is the world as it is "officially" presented to our domineering sensory system: our eyes.

3.

One could argue we live in two worlds: one that presents itself to us by physical and spatial experience (all of which is present), and one that is re-presented to us by others (all of which is absent). But the latter absorbs the first. The indirect world occupies excessively more mind-space time than the immediate world. That is not to say we pull *terra firma* from under our feet. However, we do pull from under our feet what Egon Brunswik has called our *ratiomorphological apparatus*[1] to make us see what we are doing and saying.

[1] The hereditary programs that influence and determine our conscious representations and expectations by which we approach the world in which we live.

4.

Luhmann's synopsis of our world draws the knowledge we believe we receive from the world as round as the world we live on, no differently than what every drawing inevitably simulates: the *third* dimension. If Luhmann's synopsis applies, a new formalism in contemplating the world has developed. Operated by forms implemented through technologies of mass production which, in turn, are used by facilities of society in order to distribute knowledge. In short: a centrally regulated logical description of the world has developed: "world we *live in*" rather than "*live on*." This formalism depends on the technologies necessary to communicate with a generalized mass in absence. A *John Q. Public-world* design; a CocaCola of meaning; alcohol in the glass of adulterated perception: an organ with a tendency to resignation.

This formalism's regulating centre is the *market*. Its executing logic are the operations necessary to maintain the *market* which, in turn, is dependent on technologies necessary to reach the system-sustaining masses. It is these technologies that lead to the differentiation of media, just as coinage led to the differentiation of economy and society.

Our *world picture* is made circular by technology. Our world picture radiates *marketwise* around itself and doesn't recognize its own back.[2] The way we approach the world follows the logic of a pattern that approaches itself. The world we live in is no longer the world we live on. It's a preformatted ideology of resemblance and equivalence: an idea observed from a mind-space shuttle. We live in a world that compensates for absence through the imputation of two cardinal-orders: qualitative and quantitative order (resemblance and generality). *Resemblance* is generated by form: the operations that close the system; *equivalence* is generated by the medium that implements form: technologies of mass distribution and communication. Two questions arise:

[2] Just as we would see ourselves from behind if we could see as far as we like, since Einstein curved space back into itself.

> *What* is ordered *why*?—quality and quantity to determine our *possibilities*.

Our world picture finally fits the word invented for it.
A *picture* presents itself in absence of what it represents.
Once we see it, we begin to extend its frame in the direction
we prefer. We invent an environment based on our personal
value and belief system guided, of course, by resemblance
and generality (the essence of "reality"). However, if every-
thing we know we know from mass media, our *values* and
belief-system stem from the same pictures we apply them to.
The frames (values and beliefs) are self-referent. They are
market-conformed. Following the geocentric and the helio-
centric, we finally arrive at a world picture with no relation
to a *natural* environment whatsoever: "mercacentric."

5.

The market (system)—with its globalization and finite number
of objects—absorbs our values to an all-embracing extent.
It becomes not only both cause and effect (within our *idée fixe*
of linear causality),[3] it further predigests our choices to a
premanufactured answer: namely *"yes."* An answer we prefer-
ably receive in Hollywood. Let's remember Stanley Kubrick's
comment: "The thing is, *Schindler's List* is about success. The
Holocaust is about failure." We are comfortably circumstanced
so as to overlook that we cannot see what we cannot see.
The *market's* lucky advantage: the common misbelief that
"no" is an alternative to *"yes."* Subject and object meld and
deprive themselves of an environment as their only rebuttal.
Karl Popper has called such a process an "immunization against
external influences and disturbances." Choices deflagrate
to a one and only "truth" which constitutes nothing but an
indicator of a successful consistency-check within the system.
Market's success embodies a dilemma for a success-oriented
society: once established, *market* has to be successful so as to
preserve the very society who established it; if *market* is
indeed successful, it becomes unnoticed and succeeds over
the successor.

[3] That it is not about the cause and the effect of the system, but about the constraints that the system constitutes in differentiation to its environment remains unnoticed.

6.

Market constitutes an all-embracing monologic system. We may recall Jean Piaget's words "…logic is the morality of thought just as morality is the logic of action…Pure reason is the arbiter both of theoretical reflection and daily practice." Such self-references are not uncommon. Referring to our dictionaries, moral and ethics are also self-referent. The *market* system has joined—although incompatible—ethics and judgement. The *yes-life-in-absence* circumcises the deindividualized "mass-members" of their immediacy. *Market* instills in us the *yes* (knowledge) of *what* to think, *why* (judgement) and *how* (morals); and it *de-educates* us to understand *what* (patterns) we are acting *for* (ethics). Private (what is possible is true) and public (what is regarded to be true is possible) are no longer distinguishable in paradox. The mass is condemned to a circular as-if game: *as if* we live a life without consequences. We are forced to live a prophecy of events that shall lead to the events of the prophecy. We arrive at Marx's ideology (rephrased): *they don't understand what they are doing it for but they are still doing it.* The *market* system developed itself within the black box that communicated between our world and our environment: in a third space. This made *market* the "*tertius gaudens*" (*rejoicing third*). In a *third* it has arranged its power following extremely complicated rules, one of which is the *power of weak bonds*, of indirect relations.

7.

Since *market* is—like any other system—an emergent and emotional structure, it can only be explained outside of itself. Considering its all-embracing value system, all attempts of analyzing *market* will unavoidably lead to more of the same. As an analogy we may imagine a blast in which the waves travel with the same speed and in the same direction as the environment. It's a *withblast*. That's what the system is already doing. What we need is a counterblast to make the system respond (react) rather than constantly pledge (pro-act). If everything succeeds, nothing succeeds anymore. The only success in a "consequentless" world in which everything

succeeds is produced by *failure*. Only that which we consider failure can break the system, can de-immunize the market by providing different values so as to give debuttals a burst. Not to destroy the market, but to add values. To blast the market out of its psychotic "*eigenbehavior*" into communication with a new environment it cannot absorb. Whenever and wherever that happens, it is of utmost importance to swim out of the oscillation between both amplitudes of the differentiation, and instead to make the differentiation itself the subject matter.

To recognize *when* such added values evolve, one can rely on the appearance of censorship, the ill-logical, paradox, *petitio principii* … to name a view. To locate *where* they happen, one may simply concentrate on everything we prematurely exclude as unseen. For that, we have to observe our observations, because decisions can only be made between that which is principally undecidable: between *value* and *value rather than value and valueless*.

We have to rethink creativity. What that means can be imagined in an analogy with the controversial concept of *Urzeugung* (primeval creation).[4]

Manifesto:

-M

Market environment breeds the state of exception because it needs to disregard laws to perform violence to uphold the *market*, and is in no way self-sustaining. Waves of corruption and privilege are excessive and produce violence and injustice. The *market's* "perfect circle" has to open perpetually to commit this violence. This is *market's* weak point.

0

Market as a *simulative system* provides the coordinates of what is possible and impossible. Those are the boundaries that must be blasted.

[4] *Urzeugung* describes the procreation of the very first organic life. No other life, not even microorganisms, exist. To refute the concept is scientifically simple, because the "nature" of science is operated by separation (Indo-European *skientia*: to seperate). If science takes a wound and sterilizes it, an infection will not occur, because the bacteria will not develop within the wound. However, we have life on Earth. Science cannot test *Urzeugung*, because it is the essential precondition of *Urzeugung* that creation of life hasn't yet happened. For example: If ultraviolet rays of the sun hit an entirely *inorganic* mixture of water, carbon dioxide and ammonia, then *organic* substances such as different kinds of sugar, and compounds that look like modules of proteins in all stages of complexity, develop. If none of these are the *first* organism—as they cannot be on Earth anymore—putrefaction immediately starts because the already existing microorganisms infect the modules. If, however, there aren't microorganisms yet, organic life (including microorganisms) arise. (Based on a description by Gotthard Günther)

M

Simulation facilitates a closure within the extraordinary. Our right as human beings is the right to imagine the extraordinary so as to implement it.

2M

Our only right within the coordinates of the *market* is to place a bet.

3M

We must look at the everyday extra-legal violence necessary to uphold the *market environment*, not just the interruptions within it.

4M

We must grasp the *market* in its totality (the whole system), not just its parts. This is not about subject and object but rather about patterns that connect to generate the system. Supposed structural anomalies of capitalism (storefront governments, environmental misdeeds, corrupt business-men) aren't anomalies—they are intrinsic operations of the system. It is the *market environment* that is flawed, not only the executives. Media describes them as anomalies because they enforce the system.

5M

"Truth is the invention of a liar" (Heinz von Foerster). To confront the market, truth must be regarded futile. *Market* is a cynic: it already knows this and acts despite this.

6M

"They don't know what they are doing but they are doing it." (Marx).

7M

They know very well what they are doing, but still, they are still doing it (cynic).

8M

They know very well what they're doing but they are doing it, because they don't know what they're doing it *FOR*.

9M

Our contemporary landscape is the latest version of Norbert Wiener's system.

10M

There was a moment in time when *Cybernetics* and *Systems Theory* had to touch art (e.g., John Cage, Andy Warhol, Buckminster Fuller, Gordon Pask), architecture (e.g., architectural program) and design (e.g., marketing). In the backpack of *Cybernetics* and *Systems Theory*—considering these disciplines to be of military origin—lurked concepts like target (group), error control and simulation. Today, art, architecture, design and their education owe what they have become to these driving concepts. What has started with LSD at elite universities in the U.S. has barely found its way out of Wiener's "the science of control and communication, in the animal and in the machine," triggering a social utopia based on total regulation. In other words: since Wiener updated the Cartesian machine with feedback, feedforward and a black box, it seems hardly possible for the arts not to give in to the temptation of predictability. Arts as "a thing that also indicates something else to combine this other with the mere thingness" (Heidegger) became a modern Artemis: instead of combining, she shoots her arrows more gruesome than gracious into the dark thicket of knowledge trees. Systems have become atmospheric, even meteorological; they permeate our lives. We are the objects of their marketing, traversing inside architectural programs (no more plans), and viewing pitiless art that at best reveals to us the feedback loop that tries to calculate for our known and unknown, rational and irrational subjectivities.

11M

We have to find a way of primeval creativity that is—from the

180

[5] Postface, *Six Years: The Dematerialization of the Art Object from 1966 to 1972*, Berkeley: University of California Press, 1973.

beginning—stable enough to withstand the already existing microorganisms of the market. Conceptual art was its great praxis but even Lucy Lippard[5] acknowledged conceptual art's failure. The Xeroxes of ideas that were imagined but never performed sell for obscene sums. Our present experimentation must continuously imagine and work for an unabsorbable creativity. Otherwise, we are trapped in Gerhard Polt's freedom: "Freedom is the thought that we are able to choose between supply and demand."

CAMERON CRAWFORD

———

Part one.

Elegance is refusal. And refusal is a spheroid opening. Please imagine a jug. This jug has a lid, which has always been on, and never comes off. It is permanently attached. Jug is bubble. And the bubble is a sphere, but what is covered by this is a particular thing: the inside.

It is necessary, when considering that elegance is refusal, to know that refusal is a positive. It is inside, held inside, kept apart. It is a quantity. The jug is a spheroid opening.

The jug, the actual jug, is not indestructible. It is a construction of partial atomic offerings. One of these holds the possibility of catastrophe. It is the possible catastrophe, collapse, which is the opening, and the perpetually-lidded jug which is the sphere.

The spheroid opening is on and within the ether. There are other words for the ether: the ground, the general, sex. The jug, the bubble, the refusal, the elegance, is a spheroid opening on and within the surface of the sex.

And if I say, "no"—and I say no all the time—then I make of myself a spheroid opening on and within the ground. If I say, "no", and I say no all the time, I am covering my inside. I am a bubble covering this particular thing, a positive.

In this case, I am also a construction of partial offerings. Caviar. As a building would be in this case. A building the lower stories of which would be in full sun, the upper stories leaning out, shadowed, due to design, over the lower stories, and reflecting in the water, and so therefore saying "no," and this building says no all the time.

Within the particular but serial building, is the possible catastrophe. The one wall holds inside the refusal. Each brick

is a partial brick. Each brick might collapse the one wall of the building, which is on the ground. There is only one building at a time.

If I say, "no"…But if I say, "yes," then it is only ground. It is a vista of ground, and I have fallen out of the window of my car, the elegant jug, me saying no, and my clothes are mussed. There are crumbs in my lap. I am lying on the ground.

But I say, "no" all the time. So my clothes are on the ground, mussed, in the grass, and I am holding the inside, the refusal, the elegance. Then I am a spheroid opening. My lid is on (the lid has always been on, and it never comes off).

It is important to know that there is only one jug at a time. This spheroid opening can move, but the ground does not end or change. If I have a cold, and I have a cold all the time, then the refusal is inside.

The ground, understand, is a bacchanalian revel, with not a member sober. The ground does not repeat. The ground instead continues. It assents. It is dirt, grass grows in it, crumbs fall there, there is no sky—the lights are on the ground. The wheels of the jug stay closed on the ground. Please imagine that the spheroid opening does not move. It "parks. "

There is a third term: it is, "maybe." This is how the jug is built: It is partial bricks assenting to partial bricks. It is the soap, stretching around the bubble, containing the positive. And there is a fourth term: it is talking and talking. This is how the spheroid opening moves. This is how the wheels stay closed on the ground.

If I say, "maybe," and I never say maybe, it is a partial construction. Then I get back in the car, through the door. I stand up on the ground. I run my palms down the front of my clothes, the crumbs fall on the ground, I think about my hair, and I cough, and inside the car, my throat has refusal inside.

If I talk and talk, and this is what I do while I am saying no, the spheroid opening moves. It does not stop on the continuing ground, sex. It holds refusal inside.

Part two.
I am looking in the mirror so as to see the back of my hair.

"This is me saying no." I am congested, and I am holding the inside, the congestion, and I am getting ready to talk and talk. I am the spheroid opening and I am getting ready to move. I am getting dressed, in the fashion of always-dressed: but with partial clothes: closures that hold within them the possibility of opening: catastrophe. I am getting ready to not eat. I am looking at the frame in the center of the mirror.

Thusly: Please imagine that the spheroid opening does not move, it "parks," which is eating, also, which is the expectoration of the possibility of collapse. I am putting on a glove.

Yet, I say, "no" all the time, so I talk and talk. If I ate, but I never eat, I could then "park." So I must talk and talk, and this talking says "no," all the time.

How to hold "park" inside, and move the spheroid opening across the ground? This is a problem, this problem is a fifth term: it is "lovers lane." It is the stillness of the collapsing spheroid opening upon the general. It is where "maybe" (I never say maybe) turns into "yes" (I never say yes) and then I am on the ground. In the damp, reflecting in the water, with mussed clothes, and I am dirt with gravel. I then have fallen out of the window of my car.

In order to be irreplaceable, understand, one must always be different.

Part three.
A woman is closest to being naked when she is well dressed. I am putting beers in bottles into a bag. There is the dragging of a small bag of chips, across the surface of the table, into the bag. The bag of chips falls neatly into the bag, with the bottles of beer, but if the bag of chips would have missed the bag, the bag of chips would have fallen onto the ground. Chips inside the bag of chips would have broken. There would have been crumbs, held inside the bag of chips, waiting to collapse onto the grass, the ground, outside the door of the car (i.e. parking would be required, the bag of chips would open).

I am inside the car, with my hand in the glove under my thigh, on the seat of the car. I am talking and talking. The words are made in the air, outside my face, and the words

hover in the air. The wheels are open on the ground. My mouth is very full of the word, "no." This "no" is held inside by the mouth of the bottle of beer. The windows of the car are shut, there is hot air held inside the vents. I am looking in the mirror which is inside the visor. It is a superfluous case. I hold inside "my face," I say no, I cough into my hand, and hold the congestion inside.

My foot in my tights feels my tights, the inside of my shoe, the sole of my shoe, the floor mat, the nap of the fabric that covers the bottom of the floor, the vibration of the car.

My hand in the glove feels the bottle cap inside my pocket, through hand, glove, pant, pocket, gold foil, logo, aluminum. These are things on and within the surface of the spheroid opening, elegance. They are things on this surface, which themselves are closed. They are the lid of the jug, they have always been on, and they never come off.

My clothes hold the positive inside. My clothes say no. "This is me saying no. I am talking and talking." My hair has always been on it never comes off.

The Presentation Theme

JIM TRAINOR

You used to think you were the centre of everything. You thought you were the centre—but you were mistaken. More on that later.

Well then… You find yourself in an unbounded landscape, and you are walking. *Oui, comme ça.*

Actually, the landscape isn't unbounded. It is bound—at the top—and at the bottom—by horizontal lines.

So you find yourself in an open landscape, yet bound at the top and bottom by horizontal lines. And you find yourself walking. And everything is strewn with blood.

You are walking around in a state of anxiety.

Now, I should mention that the blood is represented by little dots.

We know that the dots are blood, for they are concentrated around your nose and mouth, and we know that these are the parts of you that are bleeding.

Plus you can smell and taste the blood, you can smell and taste the blood in your nose and mouth, plus you can see the little dots strewn all around the landscape.

You are walking across the landscape, but you are not alone. There—in the distance—what is it?

You are walking across an unbounded landscape, and in the distance is a snake. But it is not an ordinary snake. It is a snake with the head of a mammal.

So then—you find yourself in a landscape strewn with blood, and in the distance a snake with the head of a mammal. And body parts too.

Here, someone's leg.

And here, a severed head, a severed head still with its straps.

And we are beginning to think that this is no ordinary landscape, but rather, that there is something sacred about it, strewn as it is with blood and body parts and bound as it is with horizontal lines at the top and bottom.

So let's recap the story so far. Let's recap. You find yourself bleeding from nose and mouth, you find yourself in a ritual space, and there is a snake, a mammal-headed snake, and there are body parts, and the whole is strewn with blood.

Now, did I mention that your hair is dishevelled?

Your hair is dishevelled, and you are naked. You find yourself naked, and we take your nakedness to imply subjection and defeat.

If your nakedness can't be depicted the normal way, then your privates will be depicted on your side; someone will make sure your privates are depicted on your side, as a sign of your subjection, your subjection and your defeat.

With you, there are other naked men, also subjected and defeated (is that even a word—"subjected?"), naked men, on foot.

And also on litters. How heavy those litters are! Litters of defeated men, all naked.

It is hard to say if the injuries, if the injuries of those in the litters are worse than yours, but that would seem to make sense, for otherwise why wouldn't they be walking as you are?

On the other hand, it's hard to tell who you are, among these naked men, naked men on litters and on foot, for after all, all naked men look alike.

And now, something new—birds. Birds dressed as priests.

In the distance, in the distance of the blood-strewn landscape, you see some birds, are they birds dressed as priests?

The point is, they are dressed, whether they are birds or priests they are dressed in the robes of someone with spiritual value, while you are naked.

And now, steps.

A flight of steps, so many steps you cannot count them.

You have never seen so many steps, and here the steps are succinctly represented by the centipede, the centipede with its many legs, which insect can be made to represent the flight of steps, the legs of the insect representing the many steps.

And now you are made to climb them. The steps, I mean.

You are made to climb, and when you reach the top, there you find the priestess and the fangéd man.

You find the priestess and the fangéd man, not unexpectedly. And you find their paraphernalia, the goblet, the encrusted goblet, and also the chisel.

And it's funny, not funny ha-ha but funny strange, it is strange what you find yourself thinking, and that is: Of course, of course this is what she looks like, and the goblet, the encrusted

goblet, and the chisel, of course this is what the goblet looks like, and the fangéd man.

Though now he's hidden behind the priestess and we shall not refer to him any more.

And now there are hummingbirds, there are hummingbirds everywhere, and everywhere symbols of violent action.

Among the hummingbirds and the violent action, you look into the eyes of the priestess, and you think back upon your childhood.

And although the priestess isn't particularly feminine…

…Well, neither was your mother. Neither was your mother, who nursed you…

Your mother, who nursed you under the blanket, the attractive blanket woven of black and white checks.

And even though you are an infant, you cannot help noticing that there is a man in the room.

Father is in the room, and as you nurse at the breast of your unfeminine mother, you cannot help but notice Father, who is enjoying intercourse with your mother, but not in the normal way, not the normal way, but rather, *per anum*.

That this is occurring, that your father is enjoying intercourse *per anum*, *per anum* instead of the normal way, is incontrovertibly demonstrated in the following diagram.

And now you begin to wonder, you begin to wonder, is he really my father? He seems too spiritual to be your father.

And besides, you are disappearing.

And so it appears that even here, even here in the chamber with your mother, and the man who enjoys intercourse *per anum*, that even here, as an infant, you were always the least important player.

And now you feel the time is right, the time is right to ask the priestess a question. And so you ask, you ask the unfeminine priestess, the priestess with her chisel—

"What is it like, what will it be like after this?"

"Well," she says, "What was it like before you were born, before you nursed in your mother's arms, she with the black and white blanket?"

"Before I was born," you reply, "it was as if I had never existed."

"That's it," she says. "That's it, exactly."

CONTRIBUTORS

Academy Records
academyrecords.org

Stuart Bailey
servinglibrary.org

Andrej Blatnik
andrejblatnik.com

Elijah Burgher
ghostvomit.blogspot.com

Cameron Crawford
cameroncrawford.info

Jon Davies
jondavies.ca

Duke and Battersby
dukeandbattersby.com

Leif Elggren
leifelggren.org

Anthony Elms
anthonyelmsabsorbs.blogspot.com

Maria Fusco
mariafusco.net

Matthea Harvey
mattheaharvey.info

Nelson Henricks
nelsonhenricks.com

Mike Hoolboom
mikehoolboom.com

Irena Knezevic
allyouknowistrue.net

Erin Leland
erinleland.com

Jessie Mott
jessiemott.com

My Barbarian
mybarbarian.com

Christine Negus
christinenegus.com

Darren O'Donnell
mammalian.ca

Steve Reinke
myrectumisnotagrave.com

Lane Relyea
art.northwestern.edu/programs/
faculty/relyea.html

John Russell
john-russell.org

Adam Shecter
theworldofadam.com

Jim Trainor
sunshamesheadhuntingmoon.com

Ryan Trecartin
vimeo.com/trecartin

DATE D

Mercer Union is an artist-run centre
dedicated to the existence of contempo-
rary art. We provide a forum for the
production and exhibition of Canadian
and international conceptually and
aesthetically engaging art and related
cultural practices. We pursue our primary
concerns through critical activities that
include exhibitions, lectures, screenings,
performances, publications, events and
special projects.

Established and incorporated in 1979,
Mercer Union began as an artist-run centre
through the collective efforts of artists
who believed in alternative art production
and presentation. Throughout our history,
we have maintained ambitious program-
ming, exhibiting national and international
artists and presenting cultural professionals
both in formative and established stages
of their careers.

Mercer Union
A Centre for Contemporary Art
1286 Bloor Street West
Toronto, Ontario M6H 1N9
+1 416 536 1519
www.mercerunion.org

Blast Counterblast was set with
Lyon Text, designed by Kai Bernau
and published by Commercial Type
in 2009; as well as with Fakt Pro,
designed by Thomas Thiemich and
published by OurType in 2010.